THE WORLD AROUND 1900

LE MONDE EN 1900

DIE WELT UM 1900

EL MUNDO ALREDEDOR DE 1900

IL MONDO INTERNO AL 1900

DE WERELD ROND 1900

JÜRGEN SORGES

THE WORLD AROUND 1900

LE MONDE EN 1900

DIE WELT UM 1900

EL MUNDO ALREDEDOR DE 1900

IL MONDO INTERNO AL 1900

DE WERELD ROND 1900

## *KÖNEMANN*
© 2017 koenemann.com GmbH
www.koenemann.com

ÉDITIONS
PLACE DES
VICTOIRES

© Éditions Place des Victoires
6, rue du Mail – 75002 Paris
www.victoires.com
Depôt légal : 2ᵉ trimestre 2017
ISBN: 978-2-8099-1460-3

Concept, Project Management: koenemann.com GmbH
Text: Jürgen Sorges

Translation into French: Denis-Armand Canal (text)

Translations into English, Spanish, Italian, Dutch:

✗ TEXTCASE
Translation Agency
info@textcase.nl
textcase.de    textcase.eu

Art Direction: Oliver Hessmann
Layout: Christoph Eiden
Picture credits: akg-images gmbh

ISBN: 978-3-7419-1981-7 (GB)
ISBN: 978-3-7419-1979-4 (D)
ISBN: 978-3-7419-1980-0 (E)
ISBN: 978-3-7419-1983-1 (I)
ISBN: 978-3-7419-1982-4 (NL)

Printed in Spain by Liberdúplex

# Contents    Sommaire    Inhalt    Índice    Indice    Inhoud

## The World around 1900

The end of the 19th and the beginning of the 20th centuries marked a change in era, and not just for those who mark time based on the birth of Christ. There were, of course, many other calendar systems in use 1,900 years after the birth of Christ, all reflecting what was still at the time a tremendous richness of languages and cultures around the planet. For example, the Ethiopians marked 1900 AD/CE as the years 1892 and 1893, the Buddhist calendar said it was the years 2443 and 2444, and the Chinese calendar started the 77th Year of the Rat on 31 January 1900. Meanwhile, the Islamic calendar marked the turn of the twentieth century as 1317 – 18, but the Ottoman Empire used the Rumi calendar and said it was the years 1315 – 16. The Jews listed it as 5660 – 61, while the Japanese numbered the year in question as 2560, and the Iranian year 1279 began on 21 March, 1900. Nevertheless, the world has gradually settled on the "Christian" counting of years, known variously in English as *Anno Domini* (A.D.) or the *Common Era* (C.E.), just as it has long since largely adopted standard measures and weights based on the metric system. This standardization was the result of the First Industrial Revolution that transformed the planet and the way we live on it starting in the mid-18th century until the late 19th century. But as French sociologist Georges Friedmann wrote in 1936, the Second Industrial Revolution got its start already in the 1880s. It was at this time, he noted, that the breathtaking pace of high industrialization took hold especially in Europe and the United States thanks to the advent of electricity. In particular, it was the invention of the light bulb that drove this transition. For the first time, there seemed to be an infinite supply of energy resources available, with hydroelectric power joining the coal, oil, and gas that had fuelled the First Industrial Revolution. Anglo-American researchers tend to set the beginning of this Second Industrial Revolution somewhat later, with the introduction of industrial mass production, even if Henry Ford was not quite ready to produce his "Tin Lizzy" on the assembly line by 1900. But the first fast food for hungry workers had already its appearance, when the first hamburger sandwich was served at Louis's Lunch in New Haven, Connecticut in 1900. Its inventor was a certain Louis Lassen. 1900 was also the year when another man, Vladimir Ilyich Ulyanov, left his Siberian exile in Czarist Russia and sought refuge in Geneva until 1905 and then in Munich. He would then begin planning his international workers' revolution while in exile in Zurich. After rechristening himself Lenin, he led the Bolsheviks in the October Revolution seventeen years later and furthered the world's development with Communism

## Le monde en 1900

La fin du XIXe siècle et le début du XXe ne marquent pas un tournant particulier de l'Histoire pour les seuls chrétiens. Il existe beaucoup d'autres systèmes calendaires dans le monde, qui illustrent à cette même époque la richesse et la diversité des cultures et des langues du globe. L'an 1900 est ainsi fêté en Éthiopie en 1892–1893 ; c'est l'année 2443–2444 selon le calendrier bouddhique ; pour les Chinois, le 31 janvier 1900 marque le début de l'année du Rat, dans le 77e cycle des temps ; le calendrier islamique indique 1317–1318, sauf dans l'empire ottoman où le calendrier rumi – préféré par les autorités politico-religieuses – marque alors 1315–1316. Les Juifs sont en 5660–5661 depuis la création du monde, les Japonais en 2560 ; les Persans célèbrent leur Nouvel An 1279 le 21 mars. Toutefois, le monde occidental se règle sur le calendrier chrétien, de même que les poids, les mesures et les distances sont régis depuis longtemps déjà par le système métrique. Ces normes réglementaires sont les conséquences de la première révolution industrielle qui a profondément bouleversé la planète, entre le milieu du XVIIIe siècle et la fin du XIXe.

Reste cependant qu'à partir des années 1880 – selon les analyses de Georges Friedmann (1902–1977) – la deuxième révolution industrielle est déjà en marche. Le sociologue français situe le début de cette dernière avant tout en Europe et aux États-Unis, avec la phase de haute industrialisation qui accompagne l'arrivée triomphale de l'électricité. L'invention de l'ampoule électrique est déterminante. Des ressources d'énergie infinies sont désormais disponibles : au charbon, au pétrole et au gaz est venue s'adjoindre l'électricité – essentiellement d'origine hydraulique. Les chercheurs anglo-saxons préfèrent situer un peu plus tard l'avènement de cette seconde révolution industrielle, en l'assignant aux années de la première production industrielle de masse. En 1900, Henry Ford est encore loin de produire sa *Tin Lizzy* à la chaîne – mais il existe déjà le premier *fast-food* pour travailleurs affamés : c'est exactement en 1900 que le premier *hamburger* voit le jour chez Louis' Lunch, à New Haven (Connecticut). L'inventeur en est un certain Louis Lassen. Dans un tout autre univers, Lénine quitte cette même année son exil sibérien, dans la Russie tsariste, pour chercher refuge jusqu'en 1905 à Genève et dans les environs de la Maximiliansplatz, à Munich. Plus tard, c'est dans son exil zurichois, en se promenant sur Limmatkai, qu'il échafaudera ses grands projets de révolution mondiale. Dix-sept ans plus tard, sous le nom de Lénine, il mène les bolcheviques à la révolution d'Octobre et résume l'évolution de l'histoire : « le communisme, c'est les Soviets plus l'électricité. »

On n'en est pas encore là en 1900. La première vague de la mondialisation déferle certes déjà sur tous les continents,

## Die Welt um 1900

Das Ende des 19. und der Beginn des 20. Jahrhunderts markieren nicht nur nach christlicher Zeitrechnung eine besondere Zeitenwende. Natürlich existieren im Jahr 1900 n. Chr. auch noch zahlreiche andere Kalendersysteme, deren Existenz auch den um 1900 weltweit noch ungeheuren Reichtum an Sprachen und Kulturen auf der Erde repräsentieren. So feiert man das Jahr 1900 in Äthiopien mit den Jahren 1892 und 1893, die buddhistische Zeitrechnung orientiert sich an den Jahreszahlen 2443 und 2444, der chinesische Kalender beginnt am 31. Januar 1900 mit dem Jahr der Ratte im 77. Zyklus, der islamische Kalender feiert 1317 und 1318, doch im Osmanischen Reich wird der Rumi-Kalender mit dem Jahreswechsel 1315/16 bevorzugt. Der jüdische Kalender notiert 5660/61, der japanische hingegen das Jahr 2560. Im Iran beginnt das Jahr 1279 um den 21. März. Dennoch orientiert sich die Welt am christlichen Kalender, denn auch die Zeit ist, wie Maße, Gewichte und die Entfernungsmessung nach dem Urmeter, längst in globalem Maßstab normiert. Diese Normen sind Folge der ersten industriellen Revolution, die seit Mitte des 18. Jh. bis zum Ende des 19. Jh. die Erde verändert hat. Doch ab den 1880er-Jahren, so der französische Soziologe Georges Friedmann im Jahr 1936, ist bereits die zweite industrielle Revolution auf dem Vormarsch. Er setzt den Beginn dieser vor allem in Europa und in den USA atemberaubenden Phase der Hochindustrialisierung mit dem Siegeszug der Elektrizität an. Der Erfindung der Glühbirne bestimmt den Wandel. Erstmals stehen unendliche Energieressourcen zur Verfügung: Zu Kohle, Öl und Gas gesellt sich die vor allem durch Wasserkraft gewonnene Quelle Strom! Angloamerikanische Forscher legen den Beginn dieser zweiten industriellen Revolution gern etwas später auf die Jahre der ersten industriellen Massenproduktion fest. Und natürlich ist Henry Ford im Jahr 1900 noch nicht soweit, seine „Tin Lizzy" am Fließband zu produzieren. Aber es existiert bereits das erste Fast Food für hungrige Arbeiter: Exakt im Jahr 1900 erblickt das erste Hamburger-Sandwich in Louis´ Lunch in New Haven, Connecticut, das Licht der Welt. Erfinder ist ein gewisser Louis Lassen. Und ein anderer, Wladimir Iljitsch Uljanow verlässt im Jahr 1900 sein sibirisches Exil im zaristischen Russland, um bis 1905 in Genf und rund um den Maximiliansplatz in München Zuflucht zu suchen. Später wird er im Züricher Exil am Limmatkai spazierend über die Weltrevolution nachdenken. Als Lenin führt er die Bolschewiken 17 Jahre später in die Oktoberrevolution und bringt die weltgeschichtliche Entwicklung auf den Punkt: Kommunismus sei Sowjetmacht plus Elektrifizierung.

## El mundo alrededor de 1900

El final del XIX y principio del XX supusieron una transición especial, no solo en el calendario cristiano. Por supuesto que en 1900 existían multitud de calendarios, representativos de la todavía enorme riqueza de lenguajes y culturas a lo largo del globo. Así, en Etiopía 1900 se celebra como los años 1892 y 1893, en el calendario budista equivale a los años 2443 y 2444 y en el chino se comienza el 31 de enero de 1900 con el año de la rata del ciclo 77. El ciclo del calendario musulmán celebra los años 1317 y 1318, mientras que en el imperio Otomano el calendario rumi celebra el cambio de año 1315/16. El calendario judío marca el año 5660/61, el japonés sin embargo el 2560. En Irán comienza el año 1279 el 21 de marzo. Y sin embargo el mundo se orienta por el calendario cristiano; el tiempo se mide ya hace tiempo en términos globales, al igual que las medidas, pesos y distancias se miden con los patrones internacionales. Estos son consecuencia directa de la Primera Revolución Industrial, que entre la mitad del XVII y finales del XIX transformó el mundo. Y sin embargo a partir de 1880, según el sociólogo francés Georges Friedmann en 1936, comienza ya el avance de la Segunda Revolución Industrial. Sitúa el inicio de esta fase de hiperindustrialización, sobre todo en Europa y EEUU, en la conquista de la electricidad: la invención de la bombilla determina el cambio. Por primera vez se dispone de recursos energéticos inagotables: al carbón, petróleo y gas se une sobre todo la energía hidráulica. Los investigadores angloamericanos prefieren situar el inicio de esta segunda fase más tarde, con las primeras producciones industriales en masa. Por supuesto Henry Ford no está en 1900 muy lejos de producir su "Tin Lizzy" en la cadena de producción. Incluso existe ya el primer Fast Food para los trabajadores hambrientos: Exactamente en 1900 ve la luz la primera hamburguesa en el Louis' Lunch de New Haven, Connecticut. El inventor es un tal Louis Lassen. Y otro hombre, de nombre Wladimir Iljitsch Ulanow, abandona su exilio de Siberia en la Rusia zarista de 1900 para buscar, hasta 1905 en Ginebra y después en las cercanías de la Maximiliansplatz en Múnich, refugio. Después reflexionará sobre la revolución mundial en su exilio en Zúrich, paseando por los muelles del Limago. Ya como Lenin guiará a los bolcheviques 17 años después en la revolución de octubre y definirá el cambio histórico: el comunismo es poder soviético más electrificación.

Pero en 1900 todavía no estamos en ese momento. A pesar de que la primera onda de globalización ha pasado por todos los continentes, el mundo antiguo, eurocéntrico, resiste todavía. La monarquía y nobleza europeas

## Il mondo intorno al 1900

La fine del XIX e l'inizio del XX secolo non segnano soltanto una straordinaria svolta epocale dopo l'era cristiana. Naturalmente nel 1900 dopo Cristo esistono anche numerosi altri sistemi di calendario, la cui esistenza rappresenta l'enorme ricchezza di lingue e culture del pianeta anche intorno al 1900. Così in Etiopia si festeggia l'anno 1900 con gli anni 1892 e 1893, l'era buddista si orienta verso le date del 2443 e 2444, il calendario cinese inizia il 31 gennaio 1900 con l'anno del topo nel 77° ciclo, il calendario islamico festeggia gli anni 1317 e 1318, mentre nell'impero ottomano si preferisce il calendario Rumi con il Capodanno 1315/16. Il calendario ebraico registra 5660/61, quello giapponese invece l'anno 2560. In Iran l'anno 1279 comincia il 21 marzo. Tuttavia il mondo si orienta al calendario cristiano, poiché come la massa, i pesi e la misurazione delle distanze, anche il tempo viene normalizzato in base al metro standard da molto tempo su scala globale. Queste norme sono la conseguenza della prima rivoluzione industriale, che dalla metà del XVIII fino alla fine del XIX secolo ha cambiato il mondo. Ma a partire dal 1880, come disse il sociologo francese Georges Friedmann nel 1936, stava già avanzando la seconda rivoluzione industriale. Egli fissa l'inizio di questa fase vertiginosa di pesante industrializzazione, soprattutto in Europa e negli Stati Uniti, con il trionfo dell'elettricità. L'invenzione della lampadina determina il cambiamento. Per la prima volta sono disponibili risorse energetiche illimitate: al carbone, il petrolio e il gas si unisce la fonte di corrente ottenuta soprattutto grazie alla forza idraulica! Ricercatori anglo-americani stabiliscono l'inizio di questa seconda rivoluzione industriale un po' più tardi negli anni della prima produzione di massa industriale. E naturalmente Henry Ford nel 1900 non è ancora pronto a produrre la sua "Tin Lizzy" alla catena di montaggio. Ma esiste già il primo fast food per lavoratori affamati: esattamente nel 1900 appare il primo panino-hamburger al mondo nel locale Louis' Lunch a New Haven, nel Connecticut: l'inventore è un certo Louis Lassen. Wladimir Iljitsch Ulanow nel 1900 lascia il suo esilio siberiano nella Russia zarista, per cercare rifugio a Ginevra e nei dintorni della Maximiliansplatz di Monaco di Baviera fino al 1905. Più tardi egli rifletterà sulla rivoluzione mondiale passeggiando lungo il Limmat durante l'esilio a Zurigo. Quando Lenin 17 anni più tardi guidò i bolscevichi nella rivoluzione di Ottobre, lo sviluppo storico-mondiale venne al punto: il comunismo era la potenza sovietica con in più l'elettricità.

Eppure nel 1900 non si è ancora pronti per tutto questo. In tutti i continenti stava già iniziando la prima ondata della globalizzazione, eppure si affermava ancora

## De wereld rond 1900

Het einde van de negentiende eeuw en het begin van de twintigste markeren niet alleen een bijzondere overgang in de christelijke tijdrekening. Vanzelfsprekend bestonden er in 1900 nog talloze andere kalenders, die getuigden van de rond deze tijd nog altijd ongekende rijkdom aan talen en culturen op onze planeet. Zo werd de eeuwwisseling van 1900 in Ethiopië gevierd met de jaartallen 1892 en 1893, in de boeddhistische tijdrekening met de jaartallen 2443 en 2444, en begon op 31 januari 1900 in de Chinese kalender het Jaar van de Rat in de 77ste cyclus. In de islamitische jaartelling werden de jaren 1317 en 1318 gevierd, maar in het Ottomaanse Rijk gaf men de voorkeur aan de Roemi-kalender, met de jaartallen 1315/1316. In de Joodse jaartelling noteerde men 5660/5661, in de Japanse het jaar 2560, en in Iran begon het jaar 1279 op 21 maart. Desalniettemin richtte de wereld zich op de christelijke kalender, want ook de tijdwaarneming was – evenals maten, gewichten en afstanden op basis van de "oermeter" – al in een wereldwijd standaardsysteem opgenomen. Deze standaarden kwamen voort uit de eerste industriële revolutie, die vanaf halverwege de achttiende tot aan het einde van de negentiende eeuw de wereld transformeerde. Maar vanaf de jaren tachtig van de negentiende eeuw begon zich, zo stelde de Franse socioloog Georges Friedmann in 1936, al een tweede industriële revolutie af te tekenen. Dit was een periode van adembenemend snelle industrialisatie, met name in Europa en de VS, die volgens Friedmann begon met de triomf van de elektriciteit. De uitvinding van de gloeilamp was het moment waarop alles veranderde. Voor het eerst stond de mens een ogenschijnlijk oneindige energiebron ter beschikking: naast kolen, olie en gas was er nu de nieuwe elektriciteit, die vooral door waterkracht werd opgewekt. Amerikaanse en Britse historici dateren het begin van deze tweede industriële revolutie bij voorkeur iets later, in de jaren van de beginnende industriële massaproductie. Henry Ford was in 1900 weliswaar nog niet zo ver dat hij zijn "Tin Lizzy"-model aan de lopende band kon produceren, maar het eerste fast food voor de hongerige arbeider bestond al wel. Precies in 1900 werd in Louis' Lunch, in New Haven (Connecticut), de allereerste hamburger opgediend, uitgevonden door ene Louis Lassen. Een andere man, Vladimir Iljitsj Oeljanov, keerde in 1900 terug uit zijn Siberische ballingschap in het tsaristische Rusland, waarna hij in 1905 zijn toevlucht in Genève en daarna aan de Maximilianplatz in München zocht. Later zou hij in zijn ballingsoord Zürich aan de kade van het riviertje Limmat nadenken over de wereldrevolutie. En weer zeventien jaar later leidde hij als Lenin de bolsjewieken in de Oktoberrevolutie en markeerde daarmee een omslagpunt

being the power of the soviet (Russian for "council or assembly") plus electrification.

But things hadn't gotten quite that far in 1900. Even though the first wave of globalization had begun to crash ashore on all continents, it was the old Eurocentric world that continued to dominate. Monarchies and European aristocracy determined the fates of the nation-states that had been created in the 19th century and their lifestyles dominated the lives of their societies both at home and in the colonies they established around the globe. The US, meanwhile, was still not the focus of much attention, but it had already begun knocking rather loudly on the doors of the old powers. In 1900, President William McKinley signed new legislation setting the gold standard as the basis of the dollar, a move that is now understood as one of the major turning points in the history of finance. This allowed the greenback to begin serving as the world's reserve currency alongside the British pound sterling, eventually making it the most sought after banknote in the world. The standard was only abandoned in 1971 under President Richard Nixon. And McKinley's decision was confirmed by the American public, who re-elected him to office on November 6, only to be assassinated less than a year later. His vice president, Theodore Roosevelt, then took office and became another of the great US presidents.

## Rural exodus, urbanization, wave of emigration

In 1900, there were about 1.6 billion people living on the planet, only a quarter of today's world population, but still the result of what had been the world's first massive population explosion in the previous century. A century earlier there had only been 900 million people on the planet! In 1900, however, Asia alone was home to 937 million people, well over 50% of the world's population, but Europe was also densely populated, with 401 million inhabitants, one out of every four persons on earth. Significantly less populated were Africa (133 million), North America (81 million), Latin America (63 million), and Oceania (6 million). But, one should note, that the average life expectancy in 1900 was just 44 in continental Europe and 48 in Great Britain, the world's most developed nation at the time.

In Europe, the consequences of this precarious situation were unprecedented. For the first time, it was no longer possible for much of the rural population to feed themselves with subsistence farming. The social structures were also rigid and new inventions like the mechanical loom led to millions of unemployed. Hunger, disease, and poverty were the result. This led to a mass exodus to the centres of

mais le vieux monde marqué par l'européocentrisme domine encore. Les monarchies et la grande noblesse continuent de déterminer les destinées des nations nées au XIXᵉ siècle et imposent leur style à la société, dans leur pays comme dans les colonies créées dans le monde entier. Les États-Unis ne sont pas encore au centre du monde – mais ils frappent déjà avec force et insistance à la porte des grandes puissances du Vieux Monde ; en 1900, ils vont atteindre un sommet incontesté dans le monde de l'économie financière. Le 14 mars de cette année fatidique, le président William McKinley signe le *Gold Standard Act* qui garantit la valeur du dollar américain sur les réserves d'or de la banque centrale. Cela fait du « billet vert » la seconde référence monétaire mondiale, après la livre britannique. Le *Gold Standard Act* ne sera aboli qu'en 1971 par Richard Nixon. McKinley est réélu président le 6 novembre ; son vice-président est un des futurs grands hommes d'État américain : Theodore Roosevelt.

## Exode rural, urbanisation, vagues d'émigration

En 1900, la Terre est peuplée d'environ 1,6 milliard d'êtres humains. Cela ne représente certes qu'un quart de la population mondiale actuelle – mais le XIXᵉ siècle a quand même vécu une première et puissante explosion démographique : en 1800, on ne comptait que 900 millions d'habitants ! L'Asie en compte désormais à elle seule 937 millions, soit nettement plus que la moitié de la population mondiale. Mais l'Europe est également très peuplée, avec 401 millions d'êtres humains, soit le quart des habitants de la Terre. L'Afrique (133 millions), l'Amérique du Nord (81 millions), l'Amérique du Sud (63 millions) et l'Océanie (6 millions) arrivent loin derrière. Reste que l'espérance de vie moyenne en Europe continentale est de 44 ans – et de 48 ans seulement en Angleterre, le pays le plus développé.

Les conséquences de cette situation précaire sont exceptionnelles en Europe : pour la première fois dans son histoire, de nombreuses parties de la population des campagnes ne sont plus en mesure de se nourrir des produits de l'agriculture. Par ailleurs, les structures sociales se grippent ; de nouvelles inventions comme le métier à tisser mécanique jettent des millions de travailleurs au chômage. Les maladies, les famines, la pauvreté leur font cortège. Commence alors l'exode vers les centres urbains où se fait l'industrialisation : les capitales et grandes villes de l'Europe – Londres, Paris, Berlin – connaissent des afflux de population sans précédent, qui font éclater toutes les coutures. Tout le monde veut avoir sa part du bonheur que dispensent les entreprises de « l'époque des fondateurs » pour laquelle 1900 marque l'entrée dans un avenir de gloire et de prospérité.

Doch im Jahr 1900 ist es noch längst nicht soweit. Denn zwar rollte die erste Globalisierungswelle bereits über alle Kontinente, doch behauptet sich noch die alte, eurozentrisch geprägte Welt. Monarchien und Europas Hochadel bestimmen die Geschicke der im 19. Jahrhundert entstandenen Nationen und prägen durch ihren Lebensstil das Gesellschaftsleben daheim wie in den rund um den Globus entstandenen Kolonien. Noch nicht im Fokus der Weltöffentlichkeit stehen die USA. Aber sie klopfen bereits mächtig an die Türen der alten Mächte – und werden 1900 den aus heutiger Sicht unbestrittenen Höhepunkt in der Welt der Finanzwirtschaft setzen: US-Präsident William McKinley unterzeichnet am 14. März das neue Goldstandard-Gesetz. Die Deckung der Geldwährung, des US-Dollars, ist nun durch Goldreserven fixiert. Dies lässt den „Greenback" nach dem britischen Pfund zur Weltleitwährung aufsteigen. Er avanciert zur begehrtesten Banknote der Welt. Erst Richard Nixon wird das Gesetz 1971 kippen. Die US-Amerikaner bestätigen indes McKinleys Kurs: Er wird am 6. November erneut gewählt. Sein Vize-Präsident wird ein weiterer Großer, Theodore Roosevelt.

## Landflucht, Urbanisierung, Auswandererwellen

Um 1900 leben ca. 1,6 Milliarden Menschen auf der Erde. Dies ist zwar nur ein Viertel der heutigen Weltbevölkerung, doch das 19. Jh. hat eine erste, gewaltige Bevölkerungsexplosion erlebt. Um 1800 waren es nur 900 Millionen! Nun leben allein in Asien 937 Millionen Menschen, deutlich über 50 % der Weltbevölkerung. Aber auch Europa ist dicht bewohnt. Hier leben 401 Millionen, jeder vierte Erdbewohner. Daneben fallen Afrika (133 Mio.), Nordamerika (81 Mio.), Lateinamerika (63 Mio.) und Ozeanien (6 Mio.) deutlich ab. Allerdings: Die Lebenserwartung im Jahr 1900 liegt in Kontinentaleuropa bei nur 44, im hochentwickelten England bei 48 Jahren.

In Europa ist die Folge dieser prekären Situation beispiellos. Erstmals gelingt es vielen Teilen der Landbevölkerung nicht mehr, sich von der Agrarwirtschaft zu ernähren. Die gesellschaftlichen Strukturen sind zudem starr, neue Erfindungen wie der mechanische Webstuhl führen zur Arbeitslosigkeit von Millionen. Hunger, Krankheit, Armut sind die Folge. Es beginnt der Run auf die Zentren der Industrialisierung, Europas Haupt- und Großstädte. London, Paris, Berlin erleben beispiellose Zuzugswellen, platzen aus allen Nähten. Alle wollen Teilhabe am neuen Glück der Gründerzeit-Unternehmen um 1900, die durch einen ebenso beispiellosen Optimismus in eine glorreiche, erfolgreiche Zukunft geprägt ist.

determinan los destinos de las naciones creadas en el XIX, y definen el estilo de vida de sus sociedades en su país y en las colonias creadas en todo el globo. Los EEUU todavía no están en el foco de la opinión pública, pero ya llaman a las puertas de las viejas potencias, y en 1900 marcarán el, visto en retrospectiva, indiscutible punto álgido en el mundo de la economía financiera: el presidente William McKinley firma el 14 de marzo la Ley del Patrón Oro. La cobertura de su divisa, el dólar, está ahora fijada por las reservas de oro. Esto impulsa al "greenback" como divisa global por detrás de la libra esterlina. Avanza hasta ser la divisa global, y solo Richard Nixon en 1971 tumbará la ley. Los norteamericanos confirman la dirección tomada por McKinley: es reelegido el 6 de noviembre. Su vicepresidente será posteriormente uno de los grandes, Theodore Roosevelt.

## Éxodo rural, urbanización, oleadas de emigración

En 1900 la población mundial asciende a unos 1.600 millones de personas. A pesar de que esta cifra sea solo un cuarto de la población mundial en este momento, el XIX fue testigo del primer aumento sustancial de la población. En 1800 había alrededor de 900 millones. En 1900 viven en Asia 937 millones de personas, más del 50% de la población mundial. Pero también Europa está densamente poblada: aquí viven 401 millones, una de cada cuatro personas. Junto a estos África (133 millones), Norteamérica (81), Latinoamérica (63) y Oceanía (6) presentan cifras claramente más bajas. Sin embargo la esperanza de vida del 1900 en la Europa continental es de 44 años, en la avanzada Inglaterra de 48.

Esta precaria situación tiene consecuencias nunca vistas en Europa. Muchas partes de la población rural no pueden alimentarse de la economía agrícola. La estructuras sociales son además rígidas, invenciones como el telar mecánico dejan a millones en paro. Las consecuencias son hambre, enfermedad y pobreza. Comienza entonces el éxodo hacia los centros de la industrialización, las capitales y grandes ciudades europeas. Londres, París, Berlín reciben olas de inmigración sin precedentes que las desbordan. Todos quieren formar parte de las empresas del "Gründerzeit", alrededor de 1900, caracterizado por un optimismo sin precedentes en un futuro glorioso y triunfante.

Y así, la arquitectura se encuentra en una encrucijada: hacen falta nuevos conceptos de urbanismo, crear barrios enteros de la nada y desarrollar nuevas líneas de transporte. Y lógicamente se crece hacia arriba, puesto

il vecchio mondo di stampo eurocentrico. Le monarchie e l'aristocrazia europee stabiliscono i destini delle nazioni fondate nel XIX secolo e caratterizzano la vita sociale con il loro stile di vita, a casa propria e nelle colonie fondate intorno al mondo. Gli Stati Uniti non sono ancora al centro dell'opinione pubblica mondiale, ma bussano già fortemente alla porta delle vecchie potenze, e nel 1900 stabiliscono il culmine indiscusso, dal punto di vista odierno, nel mondo finanziario: il 14 marzo il presidente americano William McKinley firma la nuova legge del gold standard. La copertura della valuta del dollaro americano viene fissata tramite le riserve auree. In questo modo il "biglietto verde" surclassa la sterlina britannica come valuta per gli scambi internazionali, diventando la banconota più richiesta del mondo. Solo Richard Nixon ribalterà la legge nel 1971. Gli americani confermano intanto il corso McKinley: il 6 novembre viene rieletto. Il suo vice-presidente diventa un personaggio ancora più importante: Theodore Roosevelt.

## Esodo dalle campagne, urbanizzazione, ondate di migrazione

Intorno al 1900 sulla Terra vivono circa 1,6 miliardi di persone. È vero che si tratta solo di un quarto della popolazione mondiale di oggi, eppure il XIX secolo ha conosciuto una prima enorme esplosione di popolazione. Verso il 1800 c'erano soltanto 900 milioni di persone! Nel 1900 vivono solo in Asia 937 milioni di persone, ben oltre il 50% della popolazione mondiale. Ma anche l'Europa è densamente popolata. Qui vivono 401 milioni di persone, uno su quattro abitanti del pianeta. Inoltre avanzano nettamente l'Africa (133 mil.), il Nord America (81 mil.), l'America Latina (63 mil.) e l'Oceania (6 mil.). Tuttavia l'aspettativa di vita nel 1900 era di solo 44 anni nell'Europa continentale e di 48 anni nell'Inghilterra altamente sviluppata.

In Europa la conseguenza di questa situazione precaria è senza precedenti. Per la prima volta diverse parti della popolazione rurale non riescono più a mantenersi con l'economia agraria. Le strutture sociali sono inoltre rigide, le nuove invenzioni come il telaio meccanico causano la disoccupazione di milioni di persone. Fame, malattie e povertà sono le conseguenze. Comincia la corsa ai centri dell'industrializzazione, le capitali e grandi città europee. Londra, Parigi e Berlino conoscono ondate di immigrazione senza precedenti, tanto che saltano tutti i parametri. Tutti vogliono partecipare alla nuova fortuna dell'impresa del periodo Gründerzeit nel 1900, che grazie ad un ottimismo senza eguali si caratterizza in un futuro glorioso e ricco di successi.

in de wereldgeschiedenis: communisme is Sovjetmacht plus elektriciteit.

Maar in 1900 was dat allemaal nog ver weg. Weliswaar spoelde een eerste globaliseringsgolf over alle continenten, maar het oude, eurocentrische wereldbeeld was nog intact. De vorsten en adellijke geslachten van Europa bepaalden het lot van de negentiende-eeuwse natiestaten en beïnvloedden met hun levensstijl niet alleen het sociale leven in de Oude Wereld, maar ook in de overal op aarde ontstane koloniën. In de wereldwijde publieke opinie speelden de VS nog amper een rol, maar de Amerikanen begonnen al op de deuren van de traditionele grootmachten te kloppen – en markeerden in 1900 een hoogtepunt in de geschiedenis van de financiën: op 14 maart ondertekende president William McKinley de nieuwe Gold Standard Act, waarmee de dekking van de Amerikaanse dollar voortaan op de goudvoorraad berustte. Hierdoor werd het groene biljet na het Britse pond het sterkste bankpapier ter wereld. Pas in 1971 werd de wet door Richard Nixon weer ongedaan gemaakt. De Amerikanen beloonden McKinley voor zijn beleid: hij werd op 6 november herkozen, waarna zijn vicepresident, Theodore Roosevelt, tot een van de grote presidenten van de VS uitgroeide.

## Urbanisatie en massa-emigratie

Rond 1900 leefden circa 1,6 miljard mensen op aarde. Dit was weliswaar maar een kwart van de huidige wereldbevolking, maar in de negentiende eeuw deed zich een eerste, en enorme, bevolkingsexplosie voor. Rond 1800 telde de aarde 900 miljoen mensen, terwijl in 1900 alleen al in Azië 937 miljoen mensen leefden, ruim de helft van de wereldbevolking. Maar ook Europa was dichtbevolkt; daar leefden 401 miljoen mensen, een kwart van de wereldbevolking. Vergeleken daarmee staken Afrika (met 133 miljoen), Noord-Amerika (met 81 miljoen), Latijns-Amerika (met 63 miljoen) en Oceanië (met 6 miljoen) duidelijk bescheiden af. Maar: de levensverwachting lag op het Europese continent slechts op 44 jaar, en in het hoog ontwikkelde Engeland op 48 jaar.

In Europa waren de gevolgen van deze precaire situatie ongekend. Voor het eerst slaagden grote aantallen plattelandsbewoners er niet meer in om zich met de opbrengsten van het land te voeden. De sociale structuren waren bovendien te star, waardoor nieuwe uitvindingen als het mechanische weefgetouw tot miljoenen werklozen leidden. Honger, ziekte en armoede waren alomtegenwoordig. Er begon een grote trek naar de industriële centra, naar de grote steden van Europa. Londen, Parijs en Berlijn kregen te maken met een enorme

industrialization, Europe's capitals and other major cities. London, Paris, and Berlin all experienced unprecedented population growth and began to burst at the seams. It seemed that everyone wanted their share in the new prosperity that industrial companies were experiencing around 1900 and many developed an equally unprecedented optimism in a glorious, bright future.

And architecture found itself at a crossroads: new urban planning concepts were called for, entire neighbourhoods sprung up as if from thin air, and ways to move people back and forth across the city needed to be invented. And so it was only logical that buildings began to conquer the airspace above! That was the only way to make sure there was any free space left in the sprawling metropolises of Europe. But, despite all this activity, there was still not enough work available for everyone and many people found themselves crammed into the tenements that were quickly built to house the incoming masses. This led to massive waves of emigration from Europe around 1900, especially to the United States, but also to South America and Australia. The "American uncle" soon became legendary for his success overseas and began to provide material support to the families left behind.

Urbanization continued apace in 1900 for other reasons: The historicist styles that had dominated architecture since about 1840 only slowly began to give way to the early stirrings of Modernism. But the change was inevitable: in France, this architectural awakening came to be known as *Art Nouveau*. In the English-speaking world it was known as *Arts & Crafts* or the *Craftsman style* or also as *Art Nouveau*. In Germany and Austria it was called *Jugendstil,* in Italy *Stile Floreal,* and in Russia as *Stil Modern.*

But the stylistic pluralism of historicist architecture continued to dominate the cityscapes of Europe. Many buildings across the cities continued to copy (and update) the styles of the past, creating Neoclassicism and Gothic, Renaissance, and Baroque Revivals that referenced and copied the styles of the ancient elites to create an architecture to symbolize the power and domination of the royalty and ruling classes. The Palaces of Westminster and the Arc de Triomphe are as much a product of this era as are the new shopping arcades and palatial town homes of the upper bourgeoisie. Meanwhile, the country estates of the aristocracy continued to dominate the rural landscape. And while many were draw to the always bustling glitz and glamour of the big city, time seemed to stand still in many small towns and villages. And thus the old continued to stand its ground against all that was new around the year 1900. Indeed, it would in many places take two world wars to

C'est ainsi que l'architecture se trouve aussi à la croisée des chemins : il faut inventer de nouveaux concepts d'urbanisme, faire sortir des quartiers entiers de ville, créer de nouvelles voies de circulation et de communication. Il s'ensuit également et logiquement une croissance verticale des agglomérations : les métropoles pléthoriques et débordantes de l'Europe n'ont pas d'autre solution pour grandir que de prendre de la hauteur. Reste qu'il n'y a pas suffisamment de travail ni même de place pour tout le monde – d'où la construction des ensembles et des grands immeubles de rapport. Mais on voit aussi se multiplier les vagues d'émigration massives, surtout vers l'Amérique du Nord, mais aussi vers l'Amérique du Sud et l'Australie. La vieille Europe voit bientôt naître le mythe de « l'oncle d'Amérique » – le parent émigré qui a fait fortune outre-Atlantique et qui vient au secours fiancier de la famille restée « au pays »…

L'urbanisation reste indécise aussi en 1900 pour d'autres raisons : le style architectural historicisant, dominant depuis 1840, n'est que lentement supplanté par l'Art nouveau et les formes stylistiques de la modernité. Le changement s'installe pourtant inéluctablement dans l'architecture – appelé « Art nouveau » en France et en Belgique, *Jugendstil* dans les pays germanophones, *Stile Liberty* en Italie et *Modern* en Russie.

L'éclectisme stylistique de l'historicisme domine encore toutefois les architectures urbaines en Europe. Les édifices pastichant les styles architecturaux du passé – néo-gothique, néo-Renaissance, néo-baroque et néo-classicisme – continuent de marquer la physionomie des grandes villes, citant et copiant à l'envi les ensembles représentatifs de l'architecture royale et seigneuriale. Windsor et Westminster, l'Arc de triomphe sont les signes de cette époque, de même que les galeries commerciales et les grandes demeures de ville aux allures de manoirs. Mais tandis que l'éclat des lumières attire irrésistiblement les gens dans les grandes métropoles bourdonnantes et qui ne dorment jamais, le temps reste pratiquement immuable dans les petites villes et les villages. C'est d'ailleurs ainsi que l'ancien continue de prévaloir face au nouveau, en 1900. Bien souvent, les inventions et les progrès du tournant du siècle n'arrivent dans ces endroits qu'après la Seconde Guerre mondiale : l'électrification et l'asphalte, voire le tout-à-l'égout, n'ont même atteint que fort tard les lieux les plus reculés.

La situation paraît très différente aux États-Unis – dont la population ne cesse de croître du fait de l'immigration massive. Il manque en effet des milliers d'habitations. La situation est particulièrement grave à Chicago, où un grand incendie a pratiquement détruit la totalité du centre de la ville en 1871. Dès les années 1880, c'est ici qu'est né le premier gratte-ciel du monde, avec un bâtiment de dix

Und so steht auch die Architektur am Scheideweg: Neue stadtplanerische Konzepte müssen her, ganze Stadtviertel aus dem Boden gestampft, neue Verkehrsströme gelenkt werden. Und es geht folgerichtig auch in die Höhe! Denn nur so bleibt Platz in den ausufernden Metropolen Europas. Doch nicht für alle ist genügend Arbeit vorhanden, die qualvolle Enge in den neuentstehenden Mietskasernen kommt hinzu. So schwappen aus Europa auch 1900 massive Auswandererwellen vor allem in die USA, aber auch nach Südamerika und Australien. Legendär wird später jener „Onkel aus Amerika", der in der Fremde erfolgreich reüssiert und die daheim gebliebenen Familien materiell unterstützt.

Die Urbanisierung stockt um 1900 auch aus anderen Gründen: Nur langsam wird der seit 1840 epochebildende Architekturstil des Historismus vom Jugendstil und den Stilformen der beginnenden Moderne abgelöst. Doch der Wechsel kommt unausweichlich: In Frankreich wird man den Architekturaufbruch ins neue Jahrhundert als Art Nouveau, in Italien als Stile Floreal, in Russland als Stil Modern kennenlernen.

Noch aber dominiert der Stilpluralismus des Historismus die Stadtarchitekturen Europas. Die Bauten der die vergangenen klassischen Architekturstile kopierenden Neo-Gotik und Neorenaissance, des Neobarock und Neoklassizismus setzen weiterhin die städtebaulichen Akzente, zitieren und kopieren die vorwiegend von den antiken Eliten und dann von Königshäusern und Adel geprägten repräsentativen Ensemble der Herrschaftsarchitektur. Windsor und Westminster, der Tower oder der Arc de Triomphe stehen ebenso für diese Zeiten wie neue, mit Pomp ausgestattete Einkaufspassagen und schlossähnliche Stadtpaläste. Auf dem Lande dominieren weiterhin die Adelsbauten. Und während in den Metropolen der Lichterglanz der pulsierenden, niemals schlafenden Großstädte lockt, bleibt in den Kleinstädten und Dörfern vielfach schlicht die Zeit stehen. Und so behauptet sich um 1900 das Alte durchaus auch erfolgreich gegen das Neue. Vielfach werden die Errungenschaften von 1900 in diesen Gebieten erst nach dem Zweiten Weltkrieg eintreffen: Elektrifizierung und Asphalt, manchmal gar die Kanalisation erreichen abgelegene Orte erst spät.

Ganz anders sieht die Situation in den USA aus, deren Einwohnerzahl durch die Einwanderer ständig wächst. Abertausende Wohnungen fehlen. Besonders gravierend ist die Situation in Chicago, wo ein Großfeuer 1871 nahezu die gesamte Innenstadt zerstört. Schon in den 1880er-Jahren entstand hier mit einem zehnstöckigen Bau der erste Wolkenkratzer der Welt. Die Architekten der Stadt entwickeln fortan ihre Konzepte fort, werden als „Chicagoer

que es la única forma de gestionar el espacio en las crecientes metrópolis. Pero no hay trabajo para todos, a lo que se unen las angustiosas dimensiones de los nuevos apartamentos. Por eso en 1900 comienzan a salir de Europa oleadas masivas de emigrantes, sobre todo hacia EEUU, pero también a Sudamérica y Australia. El "tío de América" se convertirá en un tópico, el familiar que tuvo éxito en el nuevo continente y ayuda económicamente a la familia.

El proceso de urbanización se estanca en 1900 por otras razones: poco a poco el estilo arquitectónico historicista, vigente desde 1840, irá siendo sustituido por el modernismo y otros estilos de la incipiente modernidad. Y sin embargo el cambio es ineludible: en Francia se conocerá la nueva arquitectura como Art Nouveau, en Italia como Stile Floreal, en Rusia Stil Modern.

Si bien el eclecticismo del historicismo todavía domina la arquitectura de las ciudades europeas. Los edificios de estilo neogótico, neorrenacentista, neobarroco y neoclásico, copias de los estilos clásicos, siguen aportando los acentos urbanos, copiando y citando principalmente los elementos de la arquitectura señorial, característica de las antiguas élites, casas reales y nobleza. Windsor y Westminster, la Torre de Londres o el Arco de Triunfo son, junto con pomposas galerías comerciales y palacios urbanos, representativos de la época. En el campo las construcciones de la nobleza siguen dominando. Y mientras las metrópolis atraen con el palpitante brillo luminoso de la gran ciudad que nunca duerme, en las pequeñas ciudades y pueblos a menudo el tiempo parece detenerse. Así, lo antiguo se enfrenta con éxito a lo nuevo alrededor del 1900. Los avances de 1900 no llegarán a estas áreas hasta después de la Segunda Guerra Mundial: la electrificación y el asfalto, en algunos casos incluso la canalización, llegan tarde a estos lugares recónditos.

En los EEUU la situación es muy distinta: su población crece constantemente gracias a la inmigración, pero faltan miles de viviendas. La situación es especialmente grave en Chicago, donde en 1871 un fuego destruye casi todo el casco antiguo. Ya en la década de 1880 se construye aquí, con diez pisos, el primer rascacielos del mundo. Los arquitectos de la ciudad siguen desarrollando sus conceptos, que harán famosa a la "escuela de Chicago". Cien años más tarde otra escuela de Chicago haría furor, en el mundo de las finanzas mundiales. Al mismo tiempo en la economía de EEUU de aquellos años son típicos los magnates de la industria y las materias primas: el monopolista del petróleo John D. Rockefeller sigue los pasos del magnate ferroviario William Henry Vanderbilt,

E quindi anche l'architettura si trova ad un bivio: si devono trovare nuovi concetti di pianificazione urbana, interi quartieri cittadini nascono da zero, si pianificano nuovi flussi di traffico. E logicamente si va anche in altezza! Perché solo così rimane spazio nelle straripanti metropoli europee. Non soltanto non c'è lavoro sufficiente per tutti, ma si aggiunge pure la penosa ristrettezza dei nascenti casermoni di alloggi. Perciò nel 1900 dall'Europa sciamano anche ondate massicce di migrazione soprattutto negli Stati Uniti, ma anche in Sud America e Australia. Più tardi diventerà leggendario lo "zio dall'America", che trova il successo in terra straniera e sostiene materialmente le famiglie rimaste in patria.

Intorno al 1900 l'urbanizzazione ristagna anche per altri motivi: lo stile architettonico dello storicismo che si è formato a partire dal 1840 si distacca solo lentamente dallo Jugendstil e dalle forme stilistiche del primo modernismo. Eppure il cambiamento arriva inevitabilmente. In Francia la fase iniziale dell'architettura nel nuovo secolo è conosciuta come Art Nouveau, in Italia come stile floreale, in Russia come stile moderno.

Ma il pluralismo di stili dello storicismo domina ancora le architetture urbane in Europa. Gli edifici del neogotico e neorinascimento che copiano lo stile architettonico classico del passato, del neobarocco e del neoclassicismo impostano inoltre gli accenti urbanistici, citano e copiano l'insieme rappresentativo dell'architettura del potere, caratterizzato in prevalenza dalle antiche élite e poi dalle case regnanti e dalla nobiltà. Windsor e Westminster, la Torre o l'Arco di Trionfo rappresentano quindi per questi tempi le nuove gallerie commerciali create con sfarzo e i palazzi cittadini simili a castelli. Nelle campagne continuano a dominare gli edifici nobiliari. E mentre nelle metropoli attira lo sfavillio delle luci delle grandi città vivaci che non dormono mai, nelle cittadine e nei paesi il tempo continua spesso a passare lentamente. Così intorno al 1900 si afferma con successo il vecchio contro il nuovo. Spesso le conquiste del 1900 arriveranno in queste aree solo dopo la Seconda guerra mondiale: l'elettricità e l'asfalto, talvolta persino la canalizzazione raggiungono i luoghi isolati in ritardo.

Completamente diversa è la situazione negli Stati Uniti, il cui numero di abitanti cresce costantemente grazie all'immigrazione, tanto che mancano migliaia di appartamenti. Particolarmente grave è la situazione a Chicago, dove il grande incendio del 1871 distrugge quasi completamente il centro città. Già negli anni del 1880 nacque qui il primo grattacielo al mondo con un edificio di dieci piani. Gli architetti della città svilupparono da quel momento in poi i loro progetti, diventando famosi come "Scuola di Chicago". 100 anni più tardi un'altra scuola di

toestroom van mensen en barstten uit hun voegen. Iedereen wilde deelgenoot worden aan de belofte van een nieuwe tijd, gedreven door het ongekende optimisme van het vooruitgangsdenken.

En zo stond ook de architectuur op de drempel naar een nieuw tijdperk: nieuwe stedenbouwkundige concepten werden ontworpen, hele stadswijken werden uit de grond gestampt en nieuwe verkeersstromen moesten in goede banen worden geleid. En voortaan ging het ook de hoogte in. Want alleen zo kon men met de immer beperkte ruimte in Europa's uitdijende metropolen woekeren. Maar er was niet voldoende werk voor iedereen, waardoor enorme woonblokken met krappe en bedompte kamertjes in arme wijken ontstonden. Daardoor kwam vanuit Europa al in 1900 een massale emigratie op gang, vooral naar de VS maar ook naar Zuid-Amerika en Australië. Legendarisch werd "die oom uit Amerika", die in den vreemde een succesvol bestaan had opgebouwd en zijn arme familieleden in Europa financieel ondersteunde.

De urbanisatie stokte rond 1900 niet alleen als gevolg van de emigratie. De stijl van de historiserende architectuur, die sinds de jaren veertig van de negentiende eeuw gezichtsbepalend was, maakte slechts geleidelijk plaats voor nieuwe stromingen als de Jugendstil en het beginnende modernisme. De verandering was evenwel onontkoombaar: in Frankrijk werd de architectuur van de nieuwe tijd Art Nouveau, in Italië *stile floreale* en in Rusland *stil modern* genoemd. Maar het stilistische allegaartje van het historisme bepaalde nog altijd de architectuur van Europa. In de meeste bouwwerken werden traditionele architectuurstijlen uit het verleden gekopieerd en geciteerd, van neogotiek en neorenaissance tot neobarok en neoclassicisme, waarbij de machtsprojectie van de klassieke architectuur van de Oudheid en het daarop volgende representatieve stijlsysteem van vorsten en aristocraten werden nagevolgd. In deze tijd verrezen het Windsor Castle en het Westminster Palace, de Tower Bridge en de Eiffeltoren, naast weelderige nieuwe winkelpassages en kasteelachtige stadspaleizen. Op het platteland domineerden als vanouds de adellijke landgoederen. En terwijl in de Europese metropolen de altijd brandende lichten van het stadsleven lonkten, stond de tijd in de stadjes en dorpen van het platteland vaak gewoon stil. Zo wist het oude zich rond 1900 met succes te verzetten tegen het nieuwe. In veel opzichten zouden de verworvenheden van rond 1900 deze landelijke gebieden pas ná de Tweede Wereldoorlog bereiken: elektriciteit en verharde wegen, of zelfs stromend water.

Heel anders was de situatie in de VS, een land dat door de aanhoudende stroom immigranten bleef groeien. De

begin seeing these changes around 1900 being implemented. Many remote villages received electrical service, paved roads, and even sewer systems not until well into the mid-20th century.

The situation was rather different in the United States, where the population continued to explode thanks to a non-stop wave of immigration. But the US lacked adequate housing for all the new arrivals. Particularly serious was the situation in Chicago, where a large fire in 1871 had destroyed almost the entire city centre. But this created a clean slate, so to speak, that resulted in the world's first high-rise building (10 stories) being erected in the Windy City already in the 1880s. The city's architects continued to push their revolutionary ideas and created what came to be known as the Chicago School. A century later, another Chicago School caused a furore in the world of finance. At the same time, the US economy at the turn of the last century was dominated by large industrial and commodity tycoons, with oil industry monopolist John D. Rockefeller following in the footsteps of railroad tycoon William Henry Vanderbilt. But even Rockefeller, reputedly the richest man in the world at the time, was not always able to recognize the signs of the times. Even JP Morgan was only partially able to do this. It was around 1900 that the most influential private banker in the world recognized the potential of electricity for his operations. But the man who really understood how the times were changing was Andrew Carnegie. Born in Scotland to a weaver and the daughter of a shoemaker, he made steel his lifeblood. By 1900, the Carnegie Steel Company, founded just eight years earlier, had become the largest steel company in the world. Unlike Germany's steel barons, Carnegie did not focus on making cannons for the wars that would come, but instead on housing and urban development. He built his fortune on providing the steel for reinforced concrete and building structures. Millions of tons of iron and steel were need to meet the immense demand for bridges and massive industrial buildings, houses, and skyscrapers. It was not long before Chicago and New York were in a race to build the world's tallest buildings, such as New York's Flatiron Building (although it was never the tallest). The "Big Apple" meanwhile was becoming the beacon of hope in this new era.

## The political landscape around 1900

London remained the political and monetary centre at 1900. It was also the year that Elizabeth Bowes-Lyon first saw the light of the world on August 4. Later, as the wife of King George VI. and the mother of Queen Elizabeth II, she would live for almost 102 years, serving as a remarkable

étages. Les architectes de la ville développent sans tarder leurs idées et deviennent rapidement célèbres sous le nom d'« École de Chicago ». (Un siècle plus tard, une autre « École de Chicago » fera fureur – dans l'économie financière.) Dans le même temps, l'économie américaine de ces années-là est marquée par les magnats de l'industrie et des matières premières. Sur les traces du *tycoon* du chemin de fer, William Henry Vanderbilt, marche le roi du pétrole John D. Rockefeller – mais cet homme (qui est alors le plus riche du monde) n'identifie pas correctement tous les « signes » du monde moderne. Cela ne réussit guère plus à J. P. Morgan, en dépit des apparences – c'est le banquier le plus influent du monde –, même s'il reconnaît vers 1900 les potentialités de l'électricité pour ses entreprises. La plus fine mouche est ici Andrew Carnegie : écossais de naissance, fils d'un tisserand et de la fille d'un cordonnier, il fait de l'acier le secret de sa réussite. La « Carnegie Steel Company », fondée en 1892, est en 1900 le plus gros consortium métallurgique du monde. À la différence des barons allemands de l'acier, la puissance de Carnegie ne repose pas sur les canons, mais sur l'urbanisme et la construction des immeubles. Ses formules magiques s'énoncent « béton armé » et plus encore « charpente métallique ». Il faut en effet produire des millions de tonnes de fer et d'acier pour couvrir les immenses besoins en métal pour les ponts, les gigantesques bâtiments industriels, les immeubles et les gratte-ciel dont le pays a besoin. Chicago et New York rivalisent bientôt à qui aura le plus haut édifice du monde. Le « Flatiron Building » de New York est vite célèbre, même s'il n'est pas le premier dans sa catégorie. Mais c'est quand même la « Big Apple » (Grosse Pomme) – surnom affectueux de New York – qui porte et résume les espoirs de l'ère nouvelle.

## La carte politique du monde en 1900

En 1900, Londres reste en revanche le centre politique et financier du monde. Ici naît le 4 août 1900 Elizabeth Bowes-Lyon, future épouse du roi George VI et mère d'Élizabeth II : la « Queen Mum » va vivre presque 102 ans, devenant ainsi l'un des témoins les plus remarquables du xxe siècle. En 1900, la reine Victoria règne encore, dans la 64e année de sa régence, mais l'ère victorienne, avec sa société étroitement corsetée, va vers sa fin. Également impératrice des Indes (le « Joyau de la Couronne ») depuis 1871, Victoria quitte le trône et le monde en 1901.

Elle laisse derrière elle un paysage politique qui se présente – encore – comme un équilibre assez solide entre les cinq grandes puissances européennes. Au sommet, le Royaume-Uni doublé de l'Empire britannique – le plus grand empire mondial de l'Histoire – donne le ton aux « Cinq

Schule" berühmt. 100 Jahre später machte eine weitere Chicagoer Schule Furore: im Weltfinanzwesen. Zugleich ist die US-Wirtschaft jener Jahre von großen Industrie- und Rohstoffmagnaten geprägt: In die Fußstapfen des Eisenbahn-Tycoons William Henry Vanderbilt tritt der Ölmonopolist John D. Rockefeller. Doch dieser reichste Mann der Welt erkennt nicht alle Zeichen der Zeit richtig. Dies gelingt auch J. P. Morgan nur bedingt: Der einflussreichste Privatbankier der Welt erkennt um 1900 zwar das Potenzial der Elektrizität für seine Unternehmungen. Doch der Mann mit dem richtigen Riecher ist Andrew Carnegie: Der gebürtige Schotte, Sohn eines Webers und der Tochter eines Schuhmachers, erklärt Stahl zu seinem Lebenselixier. Seine 1892 gegründete Carnegie Steel Company ist 1900 der größte Stahlkonzern der Erde. Anders als Deutschlands Stahlbarone setz Carnegie nicht auf Kanonen, sondern auf den Wohnungs- und Städtebau. Seine Zauberworte hießen Stahlbeton- und mehr noch Stahlskelettbau. Millionen Tonnen Eisen und Stahl müssen her, um den immensen Bedarf an Brücken und gigantischen Industriebauten, an Häusern und Wolkenkratzern zu decken. Im Nu stehen Chicago und New York im Wettlauf um das höchste Gebäude der Welt. Berühmt wird so New Yorks Flatiron Building. Dabei ist dies „Bügeleisengebäude" (lies: „flat" „iron") nie die Nummer eins im Ranking! Überhaupt entwickelte sich „Big Apple" zu dem weltweiten Hoffnungsträger der neuen Zeit.

## Die politische Landkarte 1900

London hingegen ist im Jahr 1900 das politische und monetäre Machtzentrum der Erde. Hier erblickt am 4. August 1900 Elizabeth Bowes-Lyon das Licht der Welt. Als Gemahlin König Georgs VI. und spätere Queen Mum, Mutter Königin Elisabeth II., wird sie fast 102 Jahre leben und eine bemerkenswerte Zeitzeugin des 20. Jahrhunderts werden. Noch aber regiert Queen Victoria, 1900 in ihrem 63. und 64. Regentschaftsjahr. Doch das Viktorianische Zeitalter mit seinem steifen gesellschaftlichen Korsett neigt sich dem Ende zu. Victoria, seit 1871 auch Kaiserin des Kronjuwels Indien, wird am 22. Januar 1901 von der Weltbühne abtreten.

Sie hinterlässt eine politische Landschaft, die sich – noch – als diplomatisch meist fein austariertes Gleichgewicht der fünf europäischen Großmächte darstellt. Allen voran gibt das Vereinigte Königreich mit dem British Empire, dem größten Weltreich der Geschichte, den Takt dieser europäischen „Big Five" vor. Frankreich, das 1871 neugegründete deutsche Kaiserreich, die k.u.k.-Doppelmonarchie Österreich-Ungarn und das zaristische

y sin embargo el hombre más rico del mundo no lee con precisión los signos de su tiempo. J. P. Morgan lo consigue solo parcialmente: el influyente banquero privado reconoce en 1900 el potencial de la electricidad para sus empresas. Pero el hombre con el mejor olfato para los negocios es Andrew Carnegie. Nacido en Escocia, hijo de un tejedor y de la hija de un zapatero, dedica su vida al acero. Su Carnegie Steel Company, fundada en 1892, es en 1900 la compañía de acero más grande del mundo. Al contrario que los barones del acero alemanes, Carnegie no se centra en cañones, sino en la construcción de viviendas y el urbanismo. Sus armas mágicas son el hormigón armado, y sobre todo el "steel framing" (marcos de acero para construcción). Los puentes, casas, rascacielos y enormes construcciones industriales necesitan de millones de toneladas de hierro y acero. Chicago y Nueva York compiten en estos momentos por tener el edificio más alto del mundo, y el edificio Flatiron de Nueva York se hace famoso. ¡Sin embargo este "edificio plancha"(véase: "flat" "iron") nunca es el primero del ranking! La "gran manzana" se convertiría finalmente en el depositario de la esperanza en la nueva era a nivel mundial.

## El mapa político en 1900

Sin embargo en 1900 el centro político y monetario mundial es Londres. Aquí llega al mundo, el 4 de agosto de 1900, Elizabeth Bowes-Lyon. Como esposa del Rey Jorge VI y posteriormente Reina Madre, madre de la Reina Isabel II, vivirá casi 102 años y será una notable testigo del siglo XX. En 1900 sin embargo todavía reinaba Victoria, en los años 63 y 64 de su reinado, si bien la época victoriana, con su sociedad estrictamente encorsetada, estaba llegando a su fin. Victoria, desde 1871 también emperatriz de India, abandonará la escena internacional el 22 de enero de 1901.

Deja tras de sí un paisaje político basado -todavía- en un cuidadoso equilibrio diplomático de las cinco potencias europeas. A la cabeza, el Reino Unido y su British Empire, el imperio más grande de la historia, que marcan el paso de los "Big Five" europeos. Francia, el nuevo Imperio alemán (fundado en 1871), el Imperio austrohúngaro y la Rusia zarista trabajan por establecer su rol en el futuro. Al mismo tiempo en el Oriente próximo el Imperio otomano lleva medio siglo siendo "el enfermo del Bósforo", y esto a pesar de fuertes intentos de reforma en las últimas décadas, que se expresan también en las apariencias con el rechazo al turbante y la adopción del nuevo y funcional fez. Sin embargo, sin éxito: solo un cuarto de siglo más tarde en la república de Atatürk se considerará este mismo

Chicago fece furore nel mondo finanziario. Nel contempo in quegli anni l'economia americana era caratterizzata dai grandi magnati dell'industria e delle materie prime: il monopolista del petrolio John D. Rockefeller segue le orme del tycoon delle ferrovie Henry Vanderbilt. Eppure l'uomo più ricco del mondo non riconobbe tutti i segni del tempo. Questo avvenne solo in parte anche con J.P. Morgan: il banchiere privato più influente del mondo riconosce verso il 1900 il potenziale dell'elettricità per le sue imprese. Tuttavia l'uomo con il fiuto maggiore fu Andrew Carnegie: scozzese di nascita, figlio di un tessitore e della figlia di un calzolaio, fa dell'acciaio l'elisir della sua vita. La Carnegie Steel Company da lui fondata nel 1892 diventa il maggiore gruppo industriale dell'acciaio al mondo nel 1900. Diversamente dai baroni dell'acciaio tedeschi, Carnegie non imposta la sua attività sui cannoni, bensì sulla costruzione di case e città. La sua formula magica si chiama cemento armato e ancor più strutture di acciaio. Milioni di tonnellate di ferro e acciaio sono utilizzati per soddisfare l'immenso bisogno di ponti e giganteschi edifici industriali, di case e grattacieli. In un attimo Chicago e New York fanno a gara per gli edifici più alti del mondo. Diventa così famoso il Flatiron Building di New York. Malgrado ciò questo "edificio a ferro da stiro" (leggi: "flat" e "iron") non diventerà mai il numero uno in classifica! La "Big Apple" si evolve soprattutto nel faro di speranza globale della nuova epoca.

## La mappa politica nel 1900

Nel 1900 Londra è invece il centro del potere politico e monetario del mondo. Qui il 4 agosto 1900 viene alla luce Elizabeth Bowes-Lyon. Come consorte di re Giorgio VI e più tardi Queen Mum, la madre della regina Elisabetta II, vivrà per quasi 102 anni diventando una notevole testimone del XX secolo. Ma nel 1900 regnava ancora la regina Vittoria, nel suo 63° e 64° anno di reggenza. Tuttavia l'epoca vittoriana con i suoi rigidi corsetti imposti in società stava volgendo al termine. Vittoria, dal 1871 anche imperatrice delle Indie, fece il suo ingresso sulle scena mondiale il 22 gennaio 1901.

Lasciò una scena politica che rappresentava ancora diplomaticamente il delicato equilibrio delle cinque grandi potenze europee. In primo luogo è il Regno Unito con l'Impero Britannico, il più grande impero mondiale della storia, a dettare il ritmo di queste "grandi cinque" nazioni europee. Intanto la Francia, l'Impero Germanico rifondato nel 1871, la doppia monarchia imperialregia austro-ungarica e la Russia zarista richiedono il loro ruolo nel futuro. Allo stesso tempo a Levante il regno ottomano viene considerato già da mezzo secolo "il malato del Bosforo", nonostante i notevoli sforzi di riforma negli ultimi decenni, che si

woningnood was enorm. De situatie was vooral schrijnend in Chicago, waar een grote brand in 1871 vrijwel de gehele binnenstad in de as had gelegd. Al in de jaren tachtig van de negentiende eeuw ontstond hier een bouwwerk met tien verdiepingen: de eerste wolkenkrabber. De stadsarchitecten ontwikkelden dit concept verder en werden als "School van Chicago" wereldberoemd. Een eeuw later zou nog een andere Chicago School furore maken, in het denken over de wereldeconomie. Rond 1900 werd de Amerikaanse economie beheerst door de grote industrie- en grondstofmagnaten. De aardolietycoon John D. Rockefeller trad in de voetsporen van spoorwegmagnaat William Henry Vanderbilt, maar Rockefeller, destijds de rijkste man ter wereld, wist niet alle tekenen van de tijd goed te duiden. Dat gold ook voor J.P. Morgan, de invloedrijkste private bankier van de wereld, die rond 1900 weliswaar de mogelijkheden van elektriciteit voor zijn ondernemingen herkende, maar niet de voelsprieten had die Andrew Carnegie groot zouden maken. Carnegie, in Schotland als zoon van een wever en een schoenmakersdochter geboren, maakte staal tot zijn levensdoel. Zijn in 1892 opgerichte Carnegie Steel Company was in 1900 al het grootste staalconcern ter wereld. Anders dan de Duitse staalbaronnen gokte Carnegie niet op kanonnen, maar op staal voor de woning- en stedenbouw. Zijn toverformule was gewapend beton en, meer nog, staalskeletten voor de constructie. Miljoenen tonnen aan ijzer en staal kwamen eraan te pas om aan de immense vraag aan bruggen en reusachtige fabrieken, aan woningen en wolkenkrabbers, te voldoen. Binnen de kortste keren streden Chicago en New York om de eer het hoogste bouwwerk ter wereld te herbergen. Beroemd werd daarbij het Flatiron Building in New York, ook al was dit "strijkijzer" (flat iron) geen moment het hoogste gebouw op aarde. De koploper in deze wedren naar een nieuwe tijd werd de Big Apple.

## De politieke landkaart van 1900

In het jaar 1900 was Londen het politieke en monetaire machtscentrum van de wereld. Het was hier dat Elizabeth Bowes-Lyon op 4 augustus het levenslicht zag. Als gemalin van de latere koning George VI en als "Queen Mum", de moeder van koningin Elizabeth II, werd ze bijna 102 jaar oud en zou daarmee een opmerkelijke ooggetuige van de twintigste eeuw worden. Rond de eeuwwisseling zat koningin Victoria nog op de troon, in haar 63e en 64e regeringsjaar. Maar het Victoriaanse tijdperk, met zijn preutse sociale korset van normen, liep op zijn einde. Victoria, sinds 1871 ook keizerin van "kroonjuweel" India, verliet het wereldtoneel op haar sterfdag, 22 januari 1901. Ze liet een politiek landschap achter dat zich nog altijd als een

eyewitness of the 20th century. In 1900, Queen Victoria was still on the throne, beginning the 64th year of her reign, but the Victorian era with its rigid social corset was rapidly coming to an end. Victoria who had also been crowned Empress of India in 1871 would die in just a year's time on January 22, 1901.

She left behind a political landscape that was still marked with a delicate balance among Europe's five major powers, led by the United Kingdom, ruler of the largest empire in history. France, the newly united Germany (1871), the dual monarchy of Austria-Hungary, and czarist Russia were also fighting for their place at the table. At the same time, the Ottoman Empire had come to be known as the "sick man of Europe" for half a century, despite the considerable efforts at reform that had been made, symbolized by the switch from the ancient turban to the new, functional fez. However, it was all in vain: less than a quarter century later, this fez would come to be banned in Ataturk's Turkish Republic as a sign of ancient backwardness. The fez factories shut down.

Outside Europe, the US was beginning to set the global standard. It had just waged war against the ailing Spanish empire and claimed its colonies in Cuba, Puerto Rico, and the Philippines. On June 14, 1900, it annexed what had been the independent kingdom of Hawaii and made it the country's fiftieth state in 1959. Asia also began to undergo massive change, as Japan began its path toward industrialization, even if it was poor in natural resources. This led the Japanese on the path to war, including a naval victory over Russia in 1905 that shocked all the other great powers. This was the first time that Europe's global dominance seemed to be militarily under threat. Meanwhile, Brazil was dealing with the consequences of slavery which had only been abolished in 1888.

But there were many signs of change around 1900. France conquered Chad and split the central African kingdom with the British and the Germans, with every European power getting a slice of the pie. But things were already beginning to crumble at the outer edges of Europe's empires. In China, the Boxer Rebellion broke out and Empress Dowager Cixi withdrew into her new Summer Palace. In South Africa, the Second Boer War continued until 1902, two years after the British had declared victory in September 1900. Prisoner of war Winston Churchill, capture on November 15, 1899, would later become famous, but only after escaping in 1900 together with four bars of chocolate in his pockets! And the Boer War saw the birth of a phenomenon that would come to signify the horrors of the twentieth century more than any other: the concentration camp.

Grands » de l'Europe. La République française, l'Empire allemand refondé en 1871, la Double monarchie austro-hongroise et la Russie tsariste vont rivaliser pour assurer leur place et leur rôle à l'avenir.

Dans le même temps, au Levant, l'Empire ottoman est considéré – depuis déjà un demi-siècle – comme « l'homme malade du Bosphore », malgré de considérables efforts de réformes au cours des récentes décennies. Leur expression la plus visible s'exprime par l'abandon du turban au bénéfice du fez, moderne et fonctionnel. En vain, pourtant : un quart de siècle plus tard, dans la nouvelle République turque fondée et organisée par Mustapha Kemal « Atatürk », ce même fez sera considéré comme le symbole de la résistance à l'ordre nouveau, et interdit (parfois sous peine de mort). Les fabriques de fez ferment toutes.

En dehors de l'Eurasie, à l'échelle du monde, ce sont surtout les États-Unis qui se distinguent en 1900. En 1898, ils ont triomphé de la guerre hispano-américaine et obtiennent les Philippines, Porto Rico et Guam. L'archipel de Hawaii est annexé le 14 juin 1900 (et deviendra en 1959 le 50e État de la Fédération). L'Histoire avance aussi à grands pas en Extrême-Orient. Le Japon – pauvre en matières premières, mais stimulé par des réformes efficaces – est en pointe sur le plan de l'industrialisation. À peine cinq ans plus tard, sa victoire navale sur la Russie va effrayer toutes les grandes puissances : à l'aube du xxe siècle, c'est la domination mondiale de l'Europe qui apparaît ainsi remise en cause pour la première fois. Pendant ce temps, le Brésil est aux prises avec les conséquences de l'abolition de l'esclavage, obtenue seulement en 1898. Mais 1900 apporte aussi d'autres grandes modifications dans l'ordre du monde, en Afrique. La France s'empare du Tchad, puis se partage le vaste royaume d'Afrique centrale avec l'Angleterre et l'Allemagne. Chaque grande puissance européenne obtient désormais sa part du gâteau colonial ! Cette domination est toutefois battue en brèche aux confins de ces empires coloniaux. La révolte des Boxers éclate en Chine et l'impératrice T'seu-hi se retranche dans le nouveau palais d'Été. En Afrique du Sud, malgré les communiqués de triomphe des Anglais, la deuxième guerre des Boers dure de 1900 à 1902. Fait prisonnier le 15 novembre 1899, le jeune Winston Churchill réussit à s'évader en 1900 (avec quatre tablettes de chocolat). C'est aussi dans le contexte de cette guerre cruelle que les troupes anglaises de Lord Kitchener inventent une technique de rétention qui quatre décennies plus tard symbolisera l'une des plus grandes tragédies du xxe siècle : le camp de concentration, avec son cortège d'abominations.

Le reste de l'Europe n'est d'ailleurs pas si homogène que ne le donnerait à penser l'équilibre faussement régulateur de l'ordre social et des mariages arrangés entre les grandes

Russland ringen derweil um ihre Rolle in der Zukunft. Gleichzeitig gilt in der Levante das Osmanische Reich seit nun schon einem halben Jahrhundert als „kranker Mann am Bosporus" – dies trotz erheblicher Reformanstrengungen in den letzten Jahrzehnten, die sich auch optisch mit der Ablehnung des Turbans zugunsten des neuen, funktionalen Fes ausdrücken. Indes vergebens: Nur ein Vierteljahrhundert später wird eben dieser Fes in Atatürks neuer türkischer Republik ein Zeichen uralter Rückständigkeit sein und verboten. Die Fes-Fabriken schließen.

Außerhalb Europas macht 1900 im Weltmaßstab vor allem die USA von sich reden. Gerade erst haben sie 1989 direkt vor der Haustür im Krieg um die spanische Kolonie Kuba gesiegt. Nun wenden sie sich dem Pazifik und den Philippinen zu. Quasi am Rande wird der Hawaii-Archipel am 14. Juni 1900 annektiert und schließlich 1959 auch 50. Bundesstaat der USA. Mit großen Schritten vorwärts geht es auch im Fernen Osten: Dort schreitet ausgerechnet im rohstoffarmen, aber reformorientierten Japan die Industrialisierung voran. Kaum fünf Jahre später wird der Inselstaat mit dem Seesieg über Russland alle anderen Großmächte aufschrecken. Am Eintritt zum 20. Jahrhundert scheint erstmals Europas globale Dominanz auch militärisch bedroht. Derweil beschäftigt sich Brasilien mit den Folgen der Sklaverei, die erst 1888 abgeschafft wurde.

Doch 1900 deutet vieles auf Veränderung: Zwar setzt sich Frankreich im Tschad durch und teilt das Zentralafrikanische Reich mit Vereinigtem Königreich und Deutschem Reich. Jeder erhält seinen Teil des Kolonie-Kuchens! Doch an den äußeren Rändern der kolonialen europäischen Einflusssphären bröckelt es. In China bricht der Boxer-Aufstand aus, Kaiserin Cixi zieht sich in den neuen Sommerpalast zurück. In Südafrika wird der zweite Burenkrieg trotz Siegesmeldung der Engländer im September 1900 noch bis 1902 fortgesetzt. Der am 15. November 1899 gefangene Winston Churchill wird berühmt. Ihm gelingt 1900 die Flucht – samt vier Tafeln Schokolade! Und im Burenkrieg taucht ein Wort auf, dass wie kein anderes für die Schrecken des 20. Jh. steht: Konzentrationslager.

Auch Rest-Europa präsentiert sich nicht so homogen, wie es die äußerlich dargestellte, länderübergreifende und oft durch gewiefte Heiratspolitik untermauerte Ausgleichspolitik des europäischen Hochadels vermuten ließe. Da sind die Kleinen, etwa das belgische Königreich: Skandale machen die Runde, in wenigen Jahren wird die vorher hochgelobte belgische Kongo-Kolonie zum „Herz der Finsternis" mutieren.

Auch das geeinte Italien will eine feste Größe im Konzert der Großen sein. Noch aber steht man nicht auf

fez como un signo de tiempos pasados, y se prohibirá. Las fábricas de fez cierran.

Fuera de Europa en 1900 a nivel mundial sobre todo los EEUU dan de qué hablar. Acaban de ganar la guerra por la colonia española de Cuba en 1898, y se dirigen ahora al Pacífico y las Filipinas. Allí se anexionan el archipiélago de las islas Hawái el 14 de junio de 1900, y finalmente en 1959 se convierte en el 50º estado de EEUU. También el lejano Oriente se mueve a grandes pasos: allí avanza la industrialización, sorprendentemente en Japón, pobre en materias primas pero dispuesto a grandes reformas. Cinco años más tarde el estado insular mandará un aviso a las demás potencias con su victoria naval sobre Rusia. La supremacía global europea parece amenazada al inicio del XX, también militarmente. Mientras tanto Brasil hace frente a las consecuencias de la esclavitud, abolida en 1888.

Y sin embargo hay signos de cambio en 1900: es cierto que Francia se establece en el Chad y se reparte el Congo con el Reino Unido y el Imperio alemán. ¡Todos quieren un parte del pastel! Pero en los extremos exteriores la esfera de influencia colonial europea comienza a desmoronarse. En China estalla el levantamiento de los bóxers, y la emperatriz Cixi se recoge en su nuevo Palacio de Verano. En Sudáfrica, y a pesar de las declaraciones de victoria británicas en septiembre de 1900, la segunda guerra de los Bóeres continúa hasta 1902. Winston Churchill, capturado el 15 de noviembre de 1899, se hace famoso. Consigue escapar, en 1900, ¡a cambio de cuatro tabletas de chocolate! Y en la guerra Bóer vemos por primera vez un término que se convertirá en símbolo del estremecimiento en el XX: campo de concentración.

El resto de Europa tampoco es tan homogéneo como cabría pensar, a tenor de la política de compensación transnacional de la nobleza europea, fundamentada a través de una a menudo astuta política de matrimonios. Ahí tenemos a los países pequeños, por ejemplo el reino de Bélgica: con escándalos constantes, en pocos años la colonia del Congo belga, antes recipiente de elogios, se convertirá en "el corazón de las tinieblas".

También la unificada Italia aspira a ser titular en la liga de los grandes, pero todavía no están en la escena internacional, y dominan solo la secundaria. Pero la dominan con furia y bravura: el 14 de enero de 1900 el estreno de la ópera de Giacomo Puccini "Tosca" en Roma establece nuevos estándares.

Y el virus del nacionalismo, que infectó al XIX, sigue germinando: todavía no hay estados bálticos, Finlandia está bajo la tutela de los Zares. Tampoco Noruega es independiente, sino parte del reino de Suecia. Pero Jean

esprimono anche visivamente con il rifiuto del turbante a favore del nuovo e funzionale fez. Ma inutilmente: solo un quarto di secolo più tardi, nella nuova repubblica turca di Ata Türk, questo fez sarà considerato un segno di grande arretratezza e verrà proibito, tanto che le fabbriche che lo producono dovranno chiudere.

Fuori dall'Europa nel 1900 fanno parlare di sé su scala mondiale soprattutto gli Stati Uniti d'America. Proprio di recente, nel 1989 hanno vinto la guerra fuori la porta di casa nella colonia spagnola di Cuba. Ora si rivolgono al Pacifico e alle Filippine. Per così dire ai margini il 14 giugno 1900 viene annesso l'arcipelago delle Hawaii, che nel 1959 diventa anche l'ultimo 50° stato federato degli Stati Uniti. Anche nell'Estremo Oriente si procede a grandi passi: l'industrializzazione avanza proprio nel Giappone povero di materie prime, ma orientato alle riforme. Solo cinque anni dopo lo stato isolano farà sobbalzare tutte le altre grandi potenze con la vittoria in mare sulla Russia. All'inizio del XX secolo per la prima volta il dominio globale dell'Europa sembra minacciato militarmente. Intanto il Brasile ha a che fare con le conseguenze della schiavitù, che fu abolita soltanto nel 1888.

Eppure il 1900 fa presagire molti cambiamenti: in Ciad si afferma la Francia, che si divide il regno dell'Africa Centrale con il Regno Unito e l'Impero Germanico. Ognuno si prende la sua fetta di colonie! Tuttavia si sbriciolano i margini esterni delle sfere di influsso coloniali europee. In Cina scoppia la rivolta dei Boxer, l'imperatrice Cixi si ritira nel nuovo palazzo estivo. In Sudafrica prosegue fino al 1902 la seconda guerra dei Boeri nonostante l'annuncio di vittoria degli inglesi nel settembre 1900. Diventa famoso Winston Churchill, fatto prigioniero il 15 novembre 1899. Riesce a fuggire nel 1900, con quattro tavolette di cioccolato! E nella guerra dei Boeri riappare una parola, che come nessun'altra significa terrore nel XX secolo: campi di concentramento.

Anche il resto dell'Europa si presenta non così omogeneo come farebbe supporre la politica di bilancio rappresentata esteriormente, transnazionale e spesso corroborata dall'accorta politica matrimoniale dell'aristocrazia europea. Vi sono poi i piccoli stati, come il regno del Belgio: gli scandali si diffondono e in pochi anni la colonia del Congo belga in passato esaltata muterà in "cuore dell'oscurità".

Anche l'Italia unita sarà una forte potenza nel concerto dei grandi. Ma per il momento non è ancora sulla scena mondiale, domina soltanto nelle buche delle orchestre, pur con ritmo furioso e bravura: il 14 gennaio 1900 la prima dell'opera di Giacomo Puccini "Tosca" a Roma stabilisce nuove norme.

subtiel diplomatiek machtsevenwicht tussen de vijf Europese grootmachten liet omschrijven. De toon onder de Grote Vijf werd gezet door het Britse Rijk, het grootste wereldrijk uit de geschiedenis. Daarachter streden Frankrijk, het in 1871 heropgerichte Duitse Keizerrijk, de "koninklijke en keizerlijke" Dubbelmonarchie van Oostenrijk-Hongarije en het tsaristische Rusland om een hoofdrol. In de Levant werd het Ottomaanse Rijk al een halve eeuw als de "zieke man aan de Bosporus" gezien, ondanks drastische hervormingen in voorgaande decennia, die zich ook symbolisch uitten, bijvoorbeeld in het afrekenen met de tulband ten gunste van de zakelijke fez. Maar tevergeefs: slechts een kwart eeuw later werd ook de fez in Atatürks nieuwe Turkse republiek als teken van achterlijkheid verboden. De fez-fabrieken moesten sluiten.

Buiten Europa waren het vooral de VS die op het wereldtoneel van zich deden spreken. Nog in 1899 had de jonge republiek naast de deur de oorlog om de Spaanse kolonie Cuba gewonnen, waarna ze zich op de Stille Oceaan en de Filipijnen richtte. Bijna terloops werd op 14 juni 1900 de Hawaï-archipel geannexeerd, die uiteindelijk in 1959 als vijftigste staat in de VS werd opgenomen. Ook in het Verre Oosten verliepen de ontwikkelingen razendsnel: daar leek juist in het grondstofarme en moderniserende Japan de industrialisatie onstuitbaar. Slechts vijf jaar later zou de eilandnatie met haar marinezege op Rusland de andere grootmachten opschrikken. Aan het begin van de twintigste eeuw leek voor het eerst ook de militaire superioriteit van Europa te worden bedreigd. Intussen kampte Brazilië met de gevolgen van de slavernij, die pas in 1888 was afgeschaft.

Maar in 1900 stonden alle seinen op verandering: Frankrijk veroverde weliswaar Tsjaad en deelde het Borno-rijk in Centraal-Afrika met de Britten en Duitsers, waarbij iedereen een stukje van de Afrikaanse taart kreeg toebedeeld, maar de randen van de Europese koloniale rijken begonnen af te brokkelen. In China brak de Bokseropstand uit, waarbij keizerin Cixi zich terugtrok naar haar nieuwe zomerpaleis. In Zuid-Afrika zou de Tweede Boerenoorlog zich nog tot 1902 voortslepen, ondanks het feit dat de Britten in september 1900 de zege opeisten. Winston Churchill werd daar op 15 november 1899 gevangen genomen en maakte in 1900 naam door zijn ontsnapping – met medeneming van vier plakken chocola! In deze burgeroorlog dook voor het eerst ook een woord op waarin als geen ander de verschrikkingen van de twintigste eeuw doorklonken: "concentratiekamp".

De rest van Europa was allerminst zo homogeen als het ingewikkelde, transnationale en vaak door politieke huwelijken onderbouwde machtsevenwicht tussen de

The rest of Europe was not as homogeneous as the maps might have suggested, with transnational alliances often underpinned by the shrewd intermarriages of the royal families responsible for what proved to be a delicate balance. There were scandals among some of Europe's smaller realms, such as Belgium, as its much acclaimed Belgian Congo colony began to be revealed as a "heart of darkness".

The recently united Italy also wanted a role on the world's stage, but it was pretty relegated to leading the world of culture. It was on January 14, 1900, that Giacomo Puccini's opera "Tosca" had its première in Rome and set new standards.

And nationalism, that infectious virus of the nineteenth century, continued to mutate. The Baltic states and Finland were still under Russian rule and Norway was part of the kingdom of Sweden. But Jean Sibelius set the programmatic note with his symphonic poem "Finlandia", which premièred on July 2, 1900 in Helsinki. And Norway's Edvard Grieg drove his country's nationalist Romanticism.

Meanwhile, great crises were simmering in the Balkans, soon to boil over. The animosity between the multi-ethnic dual monarchy of Austria-Hungary and its ambitious neighbour Serbia would lead to the outbreak of war in 1914. Two previous Balkan wars had resulted in the drawing of new boundaries. The border between Italy and Austria-Hungary was a major concern. Also precarious was the relationship between France and the German Empire, which had occupied Alsace and Lorraine since 1871. In less than two decades, four of the European empires would be gone. The twentieth century also changed the eastern borders of Germany, with Gdańsk, Poznań and Wrocław becoming Polish. But the stage for these developments was set in 1900, when the German Reichstag adopted the Second Navy Law. This led to the maritime arms race with the United Kingdom and the building of the dreadnought battleships that would decide the naval side of World War I. On July 27, Kaiser Wilhelm II gave his famously disturbing speech about the "Huns" to troops setting off for China.

## World's Fair, Olympics, Transportation

Paris was the belle of the ball in 1900 as the Paris World's Fair showed the strength of the global economy and the international community of scientists and engineers. 47 million people visited the fair from April 14 to November 12. The diesel engine, escalators, and sound movies were all the sensation. On July 19, the first cars of the Paris metro began to roll. On August 6, the first phone call was placed between Paris and Berlin and on August 31 telegraphs were sent between Germany and the United States

familles de la noblesse européenne. De petits États comme le royaume de Belgique alimentent aussi la chronique des scandales : en quelques années, la colonie du Congo belge – propriété personnelle du roi et d'abord portée aux nues – devient rapidement le « cœur des ténèbres ».

L'Italie unifiée depuis un demi-siècle voudrait, elle aussi, se faire une place dans le concert des nations modernes. Elle doit toutefois – pour l'instant – se contenter de l'opéra, mais elle s'y impose avec brio : le 14 janvier 1900, le succès triomphal de la « première » de *Tosca, de* Giacomo Puccini, impose de nouveaux critères dans ce domaine.

Pendant ce temps, le virus de la pensée nationaliste né au XIXᵉ siècle continue d'infecter certaines populations. Les États baltes n'existent pas encore, la Finlande est sous la tutelle des tsars. La Norvège même n'est pas encore indépendante – et fait partie du royaume de Suède. Mais Jean Sibelius compose le poème symphonique *Finlandia,* véritable manifeste, créé le 2 juillet 1900 à Helsinki et accueilli avec enthousiasme. Et la musique du Norvégien Edvard Grieg participe au grand mouvement du romantisme nationaliste.

De puissants foyers de crise couvent cependant dans les Balkans. L'animosité et le ressentiment qui opposent le vaste empire austro-hongrois multiethnique et l'ambitieux petit royaume de Serbie déboucheront en 1914 sur la Première Guerre mondiale – après deux guerres balkaniques qui auront déjà redéfini de nouvelles frontières. Celle qui sépare l'Italie de l'Autriche-Hongrie pose aussi de nombreux problèmes ; et les rapports sont tendus entre la France et l'Allemagne qui a annexé l'Alsace et la Lorraine en 1871. Vingt ans plus tard, trois empires (d'Allemagne, d'Autriche et de Russie) et un Sultanat (ottoman) auront disparu de la scène historique. Le XXᵉ siècle va bouleverser la frontière orientale du défunt *Reich* allemand : Dantzig (Gdańsk), Posen (Poznań) et Breslau (Wrocław) sont désormais polonais. Mais des événements décisifs interviennent dès 1900 : le 12 juin, le Reichstag allemand vote la seconde loi navale. Cela va déclencher une course aux armements avec l'Angleterre, pour la construction des grands cuirassés qui seront décisifs sur mer lors de la Première Guerre mondiale. Et le 27 juillet, l'empereur Guillaume II prononce devant le corps expéditionnaire allemand qui s'embarque pour la Chine le célèbre « Discours sur les Huns » *(Hunnenrede)* dont le contenu est terrifiant.

## Exposition universelle, Olympiade, et transports

En 1900, Paris est le centre du monde. L'Exposition universelle y atteste la puissance de l'économie mondiale et de la communauté internationale des scientifiques et des ingénieurs. Du 14 avril au 12 novembre, 47 millions de personnes visitent

der Weltbühne, dominiert nur den Orchestergraben. Den allerdings furios und mit Bravour: Am 14. Januar 1900 setzt die Uraufführung von Giacomo Puccinis Oper „Tosca" in Rom neue Maßstäbe.

Und der das 19. Jh. infizierende Virus des Nationalstaatgedankens keimt weiter: Noch existieren keine baltischen Staaten, Finnland steht unter Kuratel des Zaren. Auch Norwegen ist noch nicht unabhängig – und Teil des Königreichs Schweden. Aber: Jean Sibelius komponiert seine programmatische sinfonische Dichtung „Finlandia", die am 2. Juli 1900 in Helsinki uraufgeführt wird. Und Norwegens Edvard Grieg sorgt für Fahrt in der dortigen Bewegung des Nationalromantizismus.

Große Krisenherde brodeln auf dem Balkan. Die Animositäten zwischen dem Vielvölkerstaat Österreich-Ungarn und dem ambitionierten Königreich Serbien werden 1914 in den Ersten Weltkrieg münden. Zuvor werden in zwei Balkankriegen neue Grenzen gezogen. Die Grenze zwischen Italien und Österreich-Ungarn bereitet Sorge. Prekär ist das Verhältnis zwischen Frankreich und dem Deutschen Reich, das seit 1871 Elsass und Lothringen besetzt. Zwei Dekaden später werden zwei Kaiser- und ein Zarenreich sowie das Sultanat in Istanbul untergehen. Das 20. Jh. verändert auch den Osten des Deutschen Reiches: Danzig, Posen und Breslau werden polnisch. Doch die verhängnisvolle Entwicklung beginnt schon 1900: Am 12. Juni verabschiedet der deutsche Reichstag jenes 2. Flottengesetz. Es führt zum maritimen Wettrüsten mit dem Vereinigten Königreich und zum Bau jener „Dreadnought"- („Fürchte nichts")-Schlachtschiffe, die den Ersten Weltkrieg auf See entscheiden. Am 27. Juli hält Kaiser Wilhelm II. die berühmte „Hunnenrede" vor nach China auszuschiffenden Truppen, deren Inhalt Entsetzen auslöst.

## Weltausstellung, Olympia, Verkehr

Nabel der Welt ist im Jahr 1900 Paris. Die Pariser Weltausstellung beweist die Kraft der globalen Wirtschaft und der internationalen Gemeinde der Wissenschaftler und Ingenieure. 47 Mio. Menschen besuchen vom 14. April bis zum 12. November die Schau, auf der Dieselmotor, Rolltreppe und Tonfilm die Sensation sind. Am 19. Juli rollen die ersten Waggons der Pariser Metro. Am 6. August klingelt das Telefon erstmals zwischen Paris und Berlin, am 31. August funktioniert der Telegrafenverkehr via Überseekabel zwischen dem Deutschen Reich und den USA. Während dieser Leistungsschau finden auch die 2. Olympischen Sommerspiele statt – über fünf Monate. England erlebt hingegen die Premiere des ersten Überlandbusses auf der Strecke London – Leeds.

Sibelius compone su sinfonía programática "Finlandia", que se estrena el 2 de julio de 1900. Y en Noruega Edvard Grieg impulsa el movimiento autóctono del romanticismo nacionalista.

Los Balcanes son un hervidero de focos de crisis. Las animosidades entre el estado plurinacional austro-húngaro y el ambicioso reino de Serbia terminarán llevando a la I Guerra Mundial. Previamente dos guerras de los Balcanes dejan nuevas fronteras. La frontera entre Italia y Austro-Hungría genera preocupación, y también es precaria la relación entre Francia y el Imperio alemán, que ocupa desde 1871 Alsacia y Lorena. Dos décadas más tarde caerán dos emperadores, los zares y el sultanato de Estambul. El siglo XX cambia también el este del Imperio alemán: Gdańsk, Poznań y Breslavia se hacen polacas. Pero el fatídico desenlace comienza en realidad en 1900: el 12 de junio el Parlamento alemán aprueba la Segunda Ley Naval Alemana. Esta lleva a una carrera armamentística naval con el Reino Unido y a la construcción de los acorazados "Dreadnought"-"Sin temor"- que decidirán la I Guerra Mundial en el mar. El 27 de julio el emperador Guillermo II pronunció si "discurso de los hunos" frente a tropas afincadas en China, cuyo contenido provoca indignación.

## Exposición universal, Juegos Olímpicos, Transporte

El ombligo del mundo en 1900 es París. La exposición universal parisina muestra el poder de la economía global y de la comunidad internacional de científicos e ingenieros. Unos 47 millones de personas visitan la exposición entre el 14 de abril y el 12 de noviembre, en la que el motor diésel, la escalera mecánica y las películas sonoras provocan admiración. El 19 de julio parten los primeros vagones del metro de París. El 6 de agosto suena por primera vez el teléfono entre París y Berlín, el 31 de agosto funciona en telegrama por cable marítimo entre el Imperio alemán y los EEUU. Durante esta exposición tienen también lugar los segundos juegos olímpicos (a lo largo de cinco meses). Inglaterra presencia el primer autobús interurbano con el trayecto Londres - Leeds.

El transporte parece ser el símbolo más ilustrativo de una fe en el progreso desbordante. El barco "Deutschland", botado en enero, consigue el 5 de junio la Banda Azul por la travesía del Atlántico más rápida. En los EEUU, la Baker Motor Vehicle Company produce el primer automóvil eléctrico del mundo, el "Baker Electric". El ingeniero francés François Hennebique construye el primer puente del mundo de hormigón armado, el Pont de la Manufacture sobre el río Vienne. Barcos de vapor,

E il virus infetto del XIX secolo dell'idea dello Stato Nazionale continua a germogliare: non esistono ancora gli stati baltici, la Finlandia è sotto tutela dello zar. Anche la Norvegia non è ancora indipendente, fa parte del regno di Svezia. Ma Jean Sibelius compone il suo poema sinfonico programmatico "Finlandia", che viene rappresentato per la prima volta il 2 luglio 1900 a Helsinki. E il norvegese Edvard Grieg detta il percorso nel movimento locale del romanticismo nazionale.

Grossi focolai di crisi ribolliscono nei Balcani. Le animosità tra lo stato plurinazionale di Austria e Ungheria e l'ambizioso regno di Serbia sfoceranno nel 1914 nella Prima guerra mondiale. In precedenza furono tracciati nuovi confini in due guerre dei Balcani. Il confine tra Italia e Austria-Ungheria causava preoccupazione. I rapporti erano precari tra la Francia e l'Impero Germanico, che dal 1871 possedeva l'Alsazia e la Lorena. Due decenni più tardi due imperi e un regno degli zar sarebbero tramontati, così come il sultanato di Istanbul. Il XX secolo cambiò anche la zona orientale dell'Impero Germanico: Danzica, Poznan e Breslavia divennero polacche. Eppure lo sviluppo fatale iniziò già nel 1900: il 12 giugno il Parlamento tedesco varò la seconda legge navale, che causò la corsa agli armamenti marittimi con il Regno Unito e la costruzione di una corazzata "Dreadnought" ("nessuna paura"), che decise la Prima guerra mondiale in mare. Il 27 luglio l'imperatore Guglielmo II tenne il famoso "discorso degli Unni" alle truppe in partenza per la Cina, il cui contenuto suscitò preoccupazione.

## L'esposizione universale, le Olimpiadi, il traffico

Nel 1900 Parigi è l'ombelico del mondo. L'esposizione universale di Parigi mostra la potenza dell'economia globale e le comunità internazionali di scienziati e ingegneri. 47 milioni di persone visitarono la mostra dal 14 aprile al 12 novembre, dove le novità erano il motore diesel, la scala mobile e il film sonoro. Il 19 luglio partirono i primi vagoni della metropolitana di Parigi. Il 6 agosto suonò per la prima volta il telefono tra Parigi e Berlino, il 31 agosto iniziò a funzionare il servizio telegrafico tramite cavo transatlantico tra l'Impero Germanico e gli Stati Uniti. Durante questa esposizione di opere ebbero luogo anche i 2° Giochi olimpici estivi, durante cinque mesi. L'Inghilterra sperimentò invece l'inaugurazione del primo autobus interurbano sul percorso Londra – Leeds.

Soprattutto il traffico simboleggia nel modo migliore la straripante fede nel progresso. Il "Deutschland" lanciato da Stapel a gennaio conquistò il 5 giugno il Nastro Azzurro

Europese vorstenhuizen deed voorkomen. De schandalen stapelden zich op en binnen enkele jaren zou de eerder zo geprezen Belgische kolonie "Vrijstaat-Kongo" als het "Hart der duisternis" worden gezien.
Ook het verenigde Italië werd nu een vast lid van het concert van Europese grootmachten, waarbij de Italianen echter nog niet op het wereldtoneel maar eerder in de orkestbak meespeelden. Met veel passie en bravoure: op 14 januari 1900 ging Puccini's opera *Tosca* in Rome in première en introduceerde nieuwe maatstaven.

Het typisch negentiende-eeuwse virus van het nationalisme ontkiemde verder: de Baltische staten bestonden nog niet en Finland zuchtte onder het juk van de tsaar. Ook Noorwegen was nog niet onafhankelijk, maar een deel van het koninkrijk Zweden. Jean Sibelius componeerde zijn programmatische symfonische gedicht *Finlandia,* dat op 2 juli 1900 in Helsinki in première ging. En de Noor Edvard Grieg gaf de nationalistisch-romantische beweging in zijn eigen land vleugels. Op de Balkan werd het steeds onrustiger. De vijandschap tussen de "veelvolkerenstaat" Oostenrijk-Hongarije en het ambitieuze koninkrijk Servië zou in 1914 uitmonden in de Eerste Wereldoorlog. Eerder al werden na twee Balkanoorlogen nieuwe grenzen getrokken. Ook de grensconflicten tussen Italië en Oostenrijk-Hongarije baarden zorgen. En de betrekkingen tussen Frankrijk en het Duitse Rijk, dat sinds 1871 Elzas-Lotharingen bezette, was niet minder precair. Twee decennia later waren twee keizerrijken en het Ottomaanse sultanaat van Constantinopel ten onder gegaan. De twintigste eeuw veranderde ook het oosten van het Duitse Rijk: Danzig, Posen en Breslau werden Pools: Gdańsk, Poznań en Wrocław. De onheilspellende weg naar oorlog begon al in 1900: op 12 juni werd in de Duitse Reichstag de "Tweede Vlootwet" aangenomen, het startschot voor een wapenwedloop op zee met Groot-Brittannië, dat reageerde met de bouw van slagschepen in de *Dreadnought*("Onvervaard")-klasse, die de Eerste Wereldoorlog op hoge zee zouden beslechten. En op 27 juli hield Kaiser Wilhelm II tegenover troepen die naar China werden uitgezonden zijn beruchte "Hunnenrede", waarvan de inhoud ontsteltenis wekte.

## Wereldtentoonstelling, Spelen en verbindingen

In 1900 was Parijs de navel van de wereld. De Parijse Wereldtentoonstelling toonde de kracht van de wereldwijde economie en van een internationale gemeenschap van wetenschappers en ingenieurs. Van 14 april tot 12 november bezochten 47 miljoen mensen de expositie, waarop de dieselmotor, de roltrap en de geluidsfilm hun sensationele

for the first time via undersea cables. This was also the year of the 2nd Summer Olympics, which took place in Paris over a period of five months. England, meanwhile, saw the début of the first intercity bus, which ran from London to Leeds.

Transportation and movement always seemed the best symbol of an exuberant belief in progress. The *Deutschland,* which had been launched in January, set a new record for the fastest Atlantic crossing. In the US, the Baker Motor Vehicle Company made the first electric car, known as the Baker Electric. French engineer François Hennebique built the first reinforced concrete bridge in the world: the Pont de la Manufacture over the river Vienne. Steamers, electric trams, and the first automobiles drew lots of attention. And art of flight began to be mastered as the first Zeppelin LZ 1 took off on July 2, 1900. By 1903, the Wright Brothers would be the first to fly a motor-powered airplane. German-American Gustave Whitehead actually preceded them on May 3, 1901 with his model no. 21 in Bridgeport, Connecticut.

## 1900: time to relax

In 1900, no one was thinking about the harm being done to the environment and the earth's climate. Mont Blanc, Matterhorn, and Aletsch hadn't experienced any ice melt. Japan's sacred Mount Fuji was still revered. In Europe, the well-to-do went to Karlsbad, Marienbad, and Franzensbad for the "cure". Promenades and beaches at Trouville and Granville, on the Adriatic, the south coast of England, and in Heringsdorf and Norderney became popular holiday spots, with piers and seaside architecture reflecting a new culture of insouciance and wealth. But nature was not always so gentle: the pulsating Texan town of Galveston was destroyed by a hurricane on September 8, killing 8,000 people. In ten villages near Tbilisi, Georgia, 1,000 people were killed by an earthquake on January 4. But, all in all, 1900 was a normal year! But it soon became clear that they were dancing on the edge of the abyss. Pandora's box had been opened.

l'exposition – dans laquelle le moteur diesel, l'escalier roulant et le cinéma parlant font sensation. Les premières rames du métro parisien roulent le 19 juillet ; le 6 août, la première liaison téléphonique est établie entre Paris et Berlin ; le 31 août, un câble sous-marin transatlantique assure les communications télégraphiques entre l'Allemagne et les États-Unis. Dans le même temps que cette exposition se déroulent les 2e Jeux olympiques d'été. Et l'Angleterre ouvre la première ligne d'autocars interurbains entre Londres et Leeds.

Ce sont les transports qui symbolisent le mieux la foi débordante dans le progrès. Le paquebot *Deutschland,* sorti des chantiers navals en janvier, conquiert le 5 juin le « Ruban bleu » de la traversée la plus rapide de l'Atlantique. Aux États-Unis, la Baker Motor Vehicle Company réalise la première automobile électrique du monde : la « Baker Electric ». En France, l'ingénieur François Hennebique construit sur la Vienne le premier pont en béton armé du monde. Les navires à vapeur, les tramways électriques et les premières automobiles sont d'authentiques révolutions. Le 2 juillet 1900, on s'envole : le premier zeppelin « LZ 1 » quitte le sol ! En 1903, les frères Wright réalisent le premier vol à moteur. Gustave Whitehead, germano-américain, les a peut-être précédés le 3 mai 1901 à Bridgeport (Connecticut), avec son modèle « N° 21 ».

## 1900 : insouciance et temps libre

En 1900, personne ne pense encore aux destructions de l'environnement et aux désastres climatiques. Le mont Blanc, le Cervin et le glacier d'Aletsch ne voient pas fondre leurs glaces ; le mont Fuji, montagne sacrée du Japon, est vénéré. Les Européens vont en cure à Karlsbad, Marienbad ou Franzensbad. Les promenades et les plages de Trouville et de Granville, celles de l'Adriatique et de la côte sud de l'Angleterre, ou encore de Heringsford et de Norderney, sont très fréquentées ; les embarcadères et les complexes balnéaires sont les emblèmes et les points de repère de la vie facile et de la nouvelle richesse. Pourtant la nature se fâche parfois, pourtant : le 8 septembre, la petite ville bourdonnante de Galveston (Texas) est détruite par un ouragan : 8000 personnes perdent la vie. Dans une dizaine de villages de la région de Tbilissi (Géorgie), un millier de personnes meurent le 4 janvier dans un tremblement de terre. L'un dans l'autre, pourtant, 1900 est une année tout à fait « normale » ! La boîte de Pandore est ouverte…

Überhaupt versinnbildlicht der Verkehr am besten den überbordenden Fortschrittsglauben. Die im Januar vom Stapel gelaufene „Deutschland" erobert am 5. Juni das Blaue Band für die schnellste Atlantiküberquerung. In den USA fertigt die Baker Motor Vehicle Company das erste Elektroautomobil der Welt, den „Baker Electric". Der französische Ingenieur François Hennebique baut die erste Stahlbetonbrücke der Welt, den Pont de la Manufacture über den Fluss Vienne. Dampfschiffe, Elektro-Trams und erste Automobile sind echte Hingucker. Am 2. Juli 1900 geht es sogar in die Luft! Der erste Zeppelin LZ 1 hebt vom Boden ab. 1903 werden die Gebrüder Wright zum ersten Motorflug starten. Ein Deutschamerikaner, Gustave Whitehead (Gustav Weißkopf) kommt ihnen am 3. Mai 1901 in Bridgeport (Connecticut) eventuell mit seinem Modell Nr. 21 zuvor.

## 1900: gelassene Freizeit

1900 denkt noch niemand an Umweltzerstörung und Klimakatastrophe. Montblanc, Matterhorn und Aletschgletscher kennen keinen Eisschwund. Japans heiliger Berg Fuji wird verehrt. In Europa kurt man z. B. in Karlsbad, Marienbad und Franzensbad. Promenaden und Strände von Trouville und Granville, an der Adria, Englands Südküste oder in Heringsdorf und Norderney sind rege besucht, Seebrücken und Bäderarchitektur die Wahrzeichen von Unbekümmertheit und neuem Reichtum. Allerdings verwöhnt die Natur nicht nur: Am 8. September wird das pulsierende texanische Städtchen Galveston von einem Hurrikan zerstört. 8000 Menschen sterben. In zehn Dörfern bei Tiflis (Georgien) kommen 1000 Menschen schon am 4. Januar durch ein Erdbeben um. Doch alles in allem ist 1900 ein ganz „normales" Jahr! Doch nun beginnt der Tanz auf dem Vulkan. Die Büchse der Pandora ist geöffnet.

tranvías eléctricos y los primeros automóviles capturan la atención de todo el mundo. ¡Y el 2 de julio de 1900 se pasa a los cielos! Despega el primer zepelín, el LZ 1. En 1903 los hermanos Wright realizarán el primer vuelo a motor. Un germanoestadounidense, Gustave Whitehead (Gustav Weißkopf) puede haberles precedido con su modelo núm. 21 el 3.5.1901 en Bridgeport (Connecticut).

## 1900: El sereno tiempo de ocio

Nadie piensa en 1900 todavía en catástrofes climáticas y destrucción del medio. El Mont Blanc, el Cervino y el glaciar Aletsch no conocen el deshielo. El sagrado monte Fuji en Japón sigue siendo siendo venerado. Los europeos se relajan en los balnearios de Karlsbad, Marienbad y Franzensbad, entre otros. Los paseos y playas de Trouville y Granville en el Adriático, la costa meridional de Inglaterra o las de Heringsdorf y Norderney reciben multitud de visitantes; los muelles y la llamada "arquitectura de balneario" son símbolos de la despreocupación y la riqueza. Pero la naturaleza no solo relaja: el 8 de septiembre un huracán destruye la enérgica, si bien pequeña, Galveston en Tejas, dejando 8000 muertos. En diez pueblos cerca de Tiflis (Georgia) un terremoto causa 1000 muertos el 4 de enero. A pesar de todo, en general 1900 es un año "normal". Pero empieza el baile sobre el volcán: se ha abierto la caja de Pandora.

per l'attraversamento dell'Atlantico più veloce. Negli Stati Uniti la Baker Motor Vehicle Company produsse la prima automobile elettrica al mondo, la "Baker Electric". L'ingegnere francese Francois Hennebique costruì il primo ponte in cemento armato del mondo, il Pont de la Manufacture sul fiume Vienne. I piroscafi a vapore, i tram elettrici e le prime automobili attiravano gli sguardi di tutti. Il 2 luglio 1900 si sale persino in cielo! Il primo Zeppelin LZ 1 si alza dal suolo. Nel 1903 i fratelli Wright lanciano il primo volo a motore. Un tedesco-americano, Gustave Whitehead (Gustav Weißkopf) li anticipa il 3.5.1901 a Bridgeport (Connecticut) con il suo modello n° 21.

## 1900: tranquillo tempo libero

Nel 1900 nessuno pensa ancora alla distruzione dell'ambiente e alla catastrofe climatica. Il Monte Bianco, il Cervino e il ghiacciaio dell'Aletsch non conoscono ancora il ritiro dei ghiacci. La montagna sacra giapponese del Fuji è venerata. In Europa ci si cura, ad esempio, a Karlsbad, Marienbad e Franzensbad. Le passeggiate e le spiagge di Trouville e Granville, della costa adriatica o del sud dell'Inghilterra, di Heringsdorf e Norderney sono località animate, i ponti sul mare e l'architettura balneare simboli di spensieratezza e della nuova ricchezza. Ma la natura non è solo capricciosa: l'8 settembre la vivace cittadina texana di Galveston venne distrutta da un uragano, che causò la morte di 8000 persone. In dieci villaggi di Tbilisi (Georgia) il 4 gennaio perirono 1000 persone a causa di un terremoto. Ma nel complesso il 1900 fu un anno tutto sommato "normale"! Eppure ora inizia la danza sul vulcano. Il vaso di Pandora viene aperto.

debuut maakten. Op 19 juli rolden de eerste metrowagons door de Parijse Métro. Op 6 augustus klonken de eerste telefoons aan weerszijden van de verbinding Parijs-Berlijn en op 31 augustus werd de eerste Atlantische telegraafkabel tussen de VS en het Duitse Rijk in gebruik genomen. Terwijl in Parijs de prestaties van het industriële tijdperk werden getoond, vonden daar ook de Tweede Olympische Spelen plaats – over een periode van vijf maanden! En in Engeland reed de eerste lijnbus tussen Londen en Leeds.

Het enorme optimisme van het vooruitgangsdenken bleek sowieso het duidelijkst uit dit soort nieuwe verbindingen. De pas in januari van stapel gelopen oceaanstomer *Deutschland* won op 5 juni de "Blauwe Wimpel", voor de snelste Atlantische oversteek. In de VS produceerde de Baker Motor Vehicle Company de eerste elektrische auto ter wereld, de "Baker Electric". De Franse ingenieur François Hennebique ontwierp de eerste brug van gewapend beton, de Pont de la Manufacture, over de rivier de Vienne. Oceaanstomers, elektrische trams en de eerste automobielen verbluften de wereld, maar op 2 juli 1900 koos de mens zelfs het luchtruim en steeg de eerste Zeppelin, de "LZ 1", op. In 1903 maakten de gebroeders Wright hun eerste gemotoriseerde vlucht, maar het is mogelijk dat een in Duitsland geboren Amerikaan, Gustave Whitehead (Gustav Weißkopf), hen op 3 mei 1901 in Bridgeport (Connecticut) vóór was, met een vlucht in zijn "Model Nr. 21".

## 1900: vrijetijdscultuur

In 1900 dacht nog niemand aan milieuvervuiling en klimaatverandering; de eeuwige sneeuw op de Mont Blanc en de Matterhorn en het ijs van de Aletschgletsjer smolten nog niet weg. Japans heilige berg, de Fuji, werd vereerd. In Europa kuurde men in Karlsbad, Marienbad en Franzensbad. Op de promenades en stranden van Trouville en Granville alsook aan de Engelse zuidkust, aan de Adriatische kust en in Heringsdorf en Norderney wemelde het van de dagjesmensen. Pieren en fraaie badplaatsen getuigden van onbekommerdheid en nieuwe welvaart. Maar de natuur was niet alleen zachtaardig: op 8 september werd het bruisende Texaanse havenstadje Galveston door een hurricane met de grond gelijk gemaakt. Achtduizend mensen lieten het leven. En op 4 januari kwamen in tien dorpen rond Tbilisi (Georgië) duizend mensen om door een aardbeving. Maar al met al was 1900 een normaal jaar. De dans op de vulkaan was echter al begonnen. De doos van Pandora stond op een kier.

Windsor Castle

London, Houses of Parliament

London, Westminster Abbey

London, Tower Bridge

London, Piccadilly Circus

Portsmouth-Southsea

Salisbury, Stonehenge

Blackpool

Worthing

Brighton

Plymouth, Saltash Bridge

Brixham, City view from harbour     Stadtansicht vom Hafen     Veduta della città dal porto

Vue de la ville depuis le port     Vista del puerto     stadsgezicht vanaf de haven

Torquay, Cockington Village

Yarmouth

Whitby, Staithes

Colwyn Bay

Colwyn Bay

Llandudno

Monmouthshire, Tintern Abbey

Conwy, Conwy Castle

Glasgow, St Enoch's Station

Glasgow, Glasgow Bridge

Edinburgh, Portobello

Dumfries, High Street

Dumbarton, High Street

Dunoon

Belfast, Albert Memorial Clock Tower

Portrush

Warrenpoint, The Esplanade

Dublin, College Green

Dublin, Shelbourne Hotel

Dublin, St Patrick's Cathedral

Dublin, Sackville Street, O'Connell Bridge

Waterford, The Quays

Waterford

Cork, St Patrick's Street

Amsterdam, Oudezijds Voorburgwal

Amsterdam, Rembrandtplein

Amsterdam, Dam

Rotterdam, De Passage

Rotterdam

Rotterdam

Rotterdam, Het Steiger

Bruxelles/Brussel, Théâtre Royal de la Monnaie/Koninklijke Muntschouwburg

Bruxelles/Brussel, Galeries Royales Saint-Hubert/Sint-Hubertusgalerij

Bruxelles/Brussel, Grand-Place/Grote Markt, Maison du Roi/Broodhuis, Maison des Ducs de Brabant/Hertogen van Brabant Huis

Antwerpen/Anvers, Stadhuis/L'hôtel de ville, Schelde

Antwerpen/Anvers, Onze-Lieve-Vrouwekathedraal/Cathedrale Nôtre-Dame,
Rubens Standbeeld/Rubens Monument

Bruges/Brugge, Quai du Rosaire, Belfried/Beffroi

Bruges/Brugge, Second station

Deuxième gare

Zweiter Bahnhof

Segunda estación

Seconda stazione ferroviaria

'Tweede Station'

Gand/Gent, Horse-drawn tram

Tramway à cheval

Pferdebahn

Hipódromo

Tram trainato da cavalli

renbaan

Gand/Gent, Guild houses

Maison de la guilde

Gildehäuser

Casas gremiales

Case delle corporazioni

gildehuizen

Oostende/Ostende

Oostende/Ostende, Spa hall
Hall des thermes
Kursaal
Casino kursaal
Kursaal
Kuurzool

Blankenberge/Blankenberghe

Luxembourg/Lëtzebuerg, La Passerelle

Metz, Pont des Morts

Strasbourg, Place Kléber

Mulhouse, Place du Nouveau Quartier

Besançon, Pont Battant, Église Sainte-Madeleine

Lille, Place de la Gare

Lille, Grand-Place

Calais, Old City Hall     Altes Rathaus     Vecchio municipio
L'ancien hôtel de ville     Antiguo ayuntamiento     Oude Raadhuis

Saint-Malo, Paramé

Paris, Pont de la Concorde, Place de la Concorde

Paris, Panthéon

Paris, Arc de triomphe

Chartres, Rue du Bourg

Orléans, Place du Martroi

Bordeaux, Allées de Tourny, Grande fontaine

Toulouse, Place du Capitole

Biarritz, Fishermen's Wharf        Fischerhafen                Porto dei pescatori

Quai des pêcheurs                  Puerto pesquero             vissershaven

Marseille, Quai de la Joliette

Nice, Casino de la Jetée-Promenade

Nice, colline de Cimiez, Hôtel Excelsior Régina Palace

Cannes, Old Harbour    Alter Hafen    Vecchio porto

Vieux port    Antiguo puerto    Oude Haven

Menton

Avignon, Papal palace
Palais des papes
Papstpalast
Palacio papal
Palazzo dei Papi
palais van de paus

Avignon, Hôtel de ville

Chamonix-Montblanc, Glacier    Gletscher    Ghiacciaio
La Mer de Glace    Glaciar    gletsjer

Lyon, Quartier Croix Rousse

Lyon, Quai des Célestins, Marché Saint-Antoine

Barcelona, Bullfighting    Stierkampf          Corrida
Corrida                    Corrida de toros    stierengevecht

Lisboa, Alameda de São Pedro de Alcântara, Castelo de São Jorge

Lisboa-Belém, Mosteiro dos Jerenimós

Funchal (Madeira), Cog railway     Zahnradbahn     Ferrovia a cremagliera

Chemin de fer à crémaillère     Ferrocarril de cremallera     tandradbaan

Porto, Praça de Almeida Garrett

Napoli, Piazza della Borsa

Pompei, Excavations    Ausgrabungen    Scavi
Fouilles    Excavaciones    opgravingen

Roma, Fontana di Trevi

Roma, Scalinata della trinità dei monti

Roma, Piazza Navona

Roma, Piazza del Campidoglio

Firenze, Ponte Vecchio

Firenze, Piazza della Signoria

Bologna, Torre Asinelli

Riva del Garda

Merano/Meran, Passeggiata Gilf

Bolzano/Bozen, Obstplatz, Torgglhaus

Torino, Ponte Vittorio Emanuele I, Monumento Vittorio Emanuele II

Venezia, Ponte di Rialto

Venezia, Palazzo Ducale (Palazzo Dogale)

Venezia, Palazzo Ca' d'Oro

Venezia, Piazza San Marco, Basilica di San Marco

Venezia, Canal Grande, Procession
Procession
Prozession
Procesión
Processione
processie

Helsingborg

Oslo, Stavkirke, stave church    Stabkirche           Chiesa a pali portanti

église en bois debout             Stavkirke           Staafkerk van Gol

Oslo, Karl Johans gate, Det Kongelige Slott

Oslo, Stortinget (parliament, parlement)

Norwegians in a Viking boat
Norvégiens sur un bateau viking

Norweger im Nordlandboot
Noruego en un bote de Norland

Norvegese su una barca del Nordland
Noren in een Nordlandboot

Norwegian woman in horse-drawn carriage

Femme norvégienne dans une voiture à cheval

Norwegerin in Pferdefuhrwerk

Noruego en carro a caballos

Donna norvegese sul carro di cavalli

Noorsen in een paardenrijtuig

Nærøydalen, Stalheim Hotel

Folgefonna

Geirangerfjorden

Bergen, Fish market    Fischmarkt    Mercato del pesce

Marché aux poissons    Mercado de pescado    de vismarkt

København, Kopenhagen, Rundetårn, Nikolaj Kirke

København, Kopenhagen, Hoejbro Plads

Hillerød, Frederiksborg Slot

Lübeck

Hamburg, Brooksbrücke

Hamburg, Jungfernstieg

Heringsdorf

Norderney

Berlin, Brandenburger Tor

Berlin, Gendarmenmarkt

Berlin, Unter den Linden, Neue Wache

Meissen, Burgberg

Erfurt

Dresden, Brühlsche Terrasse

Dresden, Zwinger

Dresden, Altmarkt

Kassel, Königsplatz

Kassel-Karlsaue, Orangerie

Frankfurt am Main, Rossmarkt

Frankfurt am Main, Römerberg

Frankfurt am Main, Rossmarkt, Goetheplatz

Bonn

Aachen, Münster, Pfalzkapelle

Aachen, Town hall
Hôtel de ville
Rathaus
Municipalidad
Municipio
stadhuis

Wiesbaden, Spa park     Kurpark       Parco di cura

Jardin des thermes    Parque        Kurpark

Ulm, Münster, Donau

Rothenburg ob der Tauber, Town hall    Rathaus    Municipio

Hôtel de ville    Municipalidad    stadhuis

Bamberg, Regnitz

München, Karlsplatz

Hohenschwangau, Schloss Neuschwanstein

Schaffhausen, Festung Munot

Zürich, Schweizerisches Landesmuseum

Zürich, Limmat, Limmatkai, Polytechnikum

Luzern und Pilatus.  Kapellbrücke und Wasserturm

Luzern, Kapellbrücke

Luzern

Luzern, Quai, St. Leodegar

Gemmipass, Hotel Wildstrubel

Grindelwald, Hotel Eiger

Champéry, Peasant women     Bäuerinnen     Contadine

Paysannes     Mujeres albañiles     boerinnen

Aletschgletscher (glacier)

Locarno, Madonna del Sasso, Lago Maggiore

Lugano, cable car     mit Seilbahn     con la funivia

Funiculaire     con teleférico     met kabelbaan

Salzburg, Staatsbrücke, Kapuzinerkloster

Wiesberg, Arlbergbahn, Trisannabrücke

Wien, Hofburg, Michaelertrakt

Wien, Kärntner Ring

Wien, Naschmarkt

Hřensko

Karlovy Vary

Františkovy Lázně

Mariánske Lázně

Kosice

Budapest, Tram    Straßenbahn    Tram
Tramway           Teleférico     tram

Băile Herculane

București

Bucureşti, Theater Square     Theaterplatz     Piazza del teatro

Place du Théâtre     Plaza teatro     Theaterplein

Sinaia

Blejsko jezero

Zagreb

Pula

Split

Split

Solin

Dubrovnik

Dubrovnik

Zadar

Zadar

Mostar, Roman bridge     Römerbrücke     Ponte romano

Pont romain     Puente de los romanos     Romeinse Brug

Sarajevo, Alifakovac

Kotor

Αθήνα/Athens

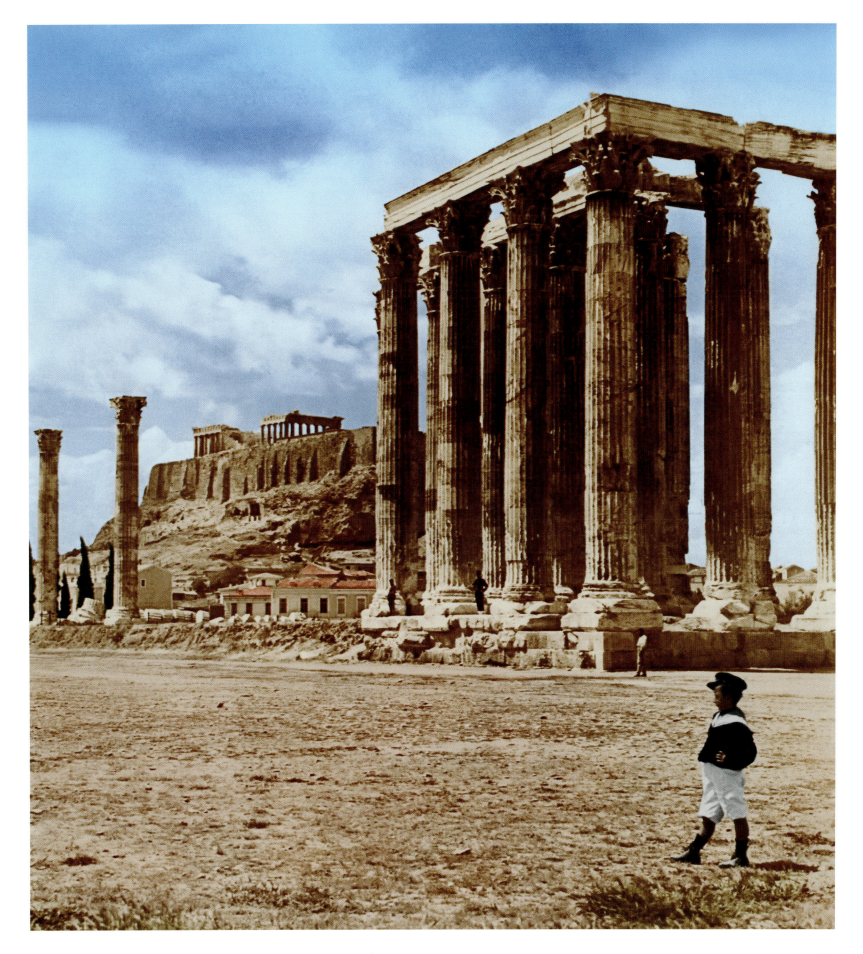

Αθήνα/Athens,
Ναός του Ολυμπίου Διός/
Temple of Olympian Zeus

Αθήνα/Athens, Ακρόπολη/Acropolis, Παρθενώνας/Parthenon

Αθήνα/Athens, Ακρόπολη/Acropolis

Warszawa, Market square in the old town

Place du marché dans la vieille ville

Marktplatz der Altstadt

Plaza del mercado en el casco antiguo

Piazza del mercato del centro storico

Marktplein in de Oude Stad

Warszawa

Wrocław, Most Tumski

Wrocław

Malbork

Gdańsk

Rīga, City Theatre    Stadttheater    Teatro comunale
Théatre de la ville    Teatro    Stadstheater

Rīga

Rīga, Quai, Daugava (Duena)

Reval – Tallinn

Helsinki

pp. 196/197 St. Petersburg

St. Petersburg, Aleksandrovskaya kolonna

St. Petersburg

Sergiyev Posad

Moscow

Moscow, Kremlin

Moscow, Demitrowka

Sevastopol

Constantinople, Galata Köprüsü

Constantinople, Çemberlitaş

Constantinople, Süleymaniye Camii

Constantinople, Beyazıt Camii

Constantinople, Sultanahmet Camii

Jerusalem

Jerusalem

Jerusalem

Jerusalem, Wandering Cobbler
Savetier itinérant
Wanderschuster
Zapatero ambulante
Calzolaio ambulante
rondtrekkende schoenlapper

Bethlehem, Market Square in front of the Nativity Church
Place du marché face à l'église de la Nativité
Marktplatz vor Geburtskirche
Plaza del mercado delante de la iglesia
Piazza del mercato davanti alla basilica della Natività
Marktplaats voor de Geboortekerk

Ramla, View from the White Tower
vue depuis la Tour Blanche
Blick vom weißen Turm
Vista desde la torre blanc
Vista dalla torre bianca
gezicht vanaf de Witte Toren

Jaffa

Jam haMelach

Delhi, Kashmiri Gate

Kolkata

Agra, Taj Mahal

China, Musicians at a Tibetan Monastery

Musikanten an einem tibetischen Kloster

Musicanti in un monastero tibetano

Musiciens dans un monastère tibétain

Músicos en un claustro tibetano

muzikanten voor een Tibetaans klooster

Great Wall of China

Beijing, Street scene
Scène de rue
Straßenszene
Escena callejera
Scene di strad
straatbeeld

China, Chinese Bicyclist
Cycliste chinois
Chinesischer Radfahrer
Ciclista chino
Ciclista cinese
Chinese fietser

Qingdao

Beijing, Children at the penny arcade
Enfants regardant à travers l'appareil d'un photographe ambulant
Kinder an mobiler Foto-Peepshow
Niños en un peepshow fotográfico ambulante
Bambini ad un foto-peepshow mobile
kinderen bij een rarekiek met foto's

China, Manchu man and woman, smoking opium
Mandchou fumant de l'opium
Manchu-Mann und -Frau, Opium rauchend
Hombre y mujer manchúes fumando opio
Uomo e donna di Manchu che fumano oppio
opium rokende man en vrouw in Mantjsoerije

Beijing, Street scene

Scène de rue

Straßenszene

Escena callejera

Scene di strada

straatbeeld

Empress Dowager Cixi (1835–1908)

Beijing, Winter Palace, Nine Dragon Wall
Palais d'Hiver, mur des Neuf Dragons
Winterpalast, Mauer der neun Drachen
Palacio invierno, Muro del nueve dragón
Palazzo inverno, Muraglia die novo drago
winter paleis, muur van de negen draken

Beijing, Water lily pond, Summer Palace
Bassin aux nymphéas, Palais d'Été
Seerosenteich, Sommerpalast
Estanque con nenúfar, Palacio verano
Laghetto ninfeo, Palazzo estivo
waterlelie-vijver, zomer paleis

Beijing, Summer Palace
Palais d'Été
Sommerpalast
Palacio verano
Palazzo estivo
zomer paleis

Beijing, Caravan at the city wall

Caravane de chameaux devant les remparts

Kamelkarawane an der Stadtmauer

Caravana de camellos en las murallas de la ciudad

Carovana di cammelli sulle mura della città

karavaan voor de stadsmuur

China, Chinese man with pushcart     Chinese mit Schubkarre     Cinese con carriola

Chinois avec une charrette à bras     Chinos con carretilla     Chinees met loopwagen

Beijing, Street scene

Scène de rue

Straßenszene

Escena callejera

Scene di strada

straatgezicht

Fuji-san

Osaka, Houses along the Kawaguchi River
Maisons le long de la rivière Kawagushi
Häuser am Kawaguchi-Fluss
Casas en el río Kawaguchi
Case sul fiume Kawaguchi
huizen aan de rivier de Kawaguchi

Osaka

Nikko

Nikko

Yokohama, 101 Steps
Escalier

Treppen der 101 Stufen
Las escaleras de los 101 escalones

Scala dei 101 gradini
de 'Trap met de 101 treden'

Dogashima

Japan, Rice farming    Reisanbau    Coltivazione di riso

Culture du riz    Campo de arroz    rijstvelden

Japan, Mussel gatherers        Muschelsammlerinnen        Raccoglitrice di cozze

Pêcheurs de moules        Recogedoras de mejillones        mosselraapsters

Japan, Teehouse with geishas
Maison de thé et geishas
Teehaus mit Geishas
Tetería con geishas
Casa da tè con geishe
theehuis met geisha's

Kyoto, Tea harvest
Cueillette du thé
Teeernte
La cosecha del té
Raccolto del tè
thee-oogst

Japan, rickshaw
Pousse-pousse
Rikscha
Rikscha
Risciò
riksja

Kyoto, Japanese garden
Jardin japonais
Japanischer Garten
Jardín japonés
Giardino giapponese
Japanse tuin

Japan, Three Japanese women

Trois Japonaises

Drei Japanerinnen

Tres japonesas

Tre donne giapponesi

Japanse vrouwen

Japan, Japanese women cooking

Femmes japonaises cuisinant

Japanerinnen beim Kochen

Japonesas cocinando

Donne giapponesi in cucina

Japanse vrouwen bij het koken

Kyoto, Shinto shrine procession

Kyoto, Honganji Temple

Kyoto, Porcelain shops
Magasins de porcelaine
Porzellanläden
Tiendas de porcelana
Negozi di porcellane
porseleinwinkeltjes

Geishas

Brisbane, Queen Street, Courier Corner

Brisbane, Albert Bridge

Sydney, Neutral Bay

Town Hall and Sturt Street, Ballarat

Ballarat

Melbourne

pp. 245/246 Los Angeles

South Perth, Zoo entrance
Entrée du zoo
Zooeingang
Entrada al zoo
Entrata dello zoo
ingang van de dierentuin

Hobart

511 724 Bird's Eye View of Los Angeles.

246

San Francisco, Golden Gate

Fresno, Drying raisins

Séchage du raisin

Rosinentrocknung

Secando uvas pasas

Essiccazione dell'uva passa

rozijnendroger

51403 THE COLUMBIA BELOW THE CASCADES        COPYRIGHT, 1901, DETROIT PHOTOGRAPHIC CO.

Columbia River

Matanuska Junction, Alaska

Denver

Georgetown, Georgetown Loop Railroad

54061. ARROW MAKER, AN OJIBWA BRAVE.

Arizona, Ojibwa bow maker
Homme fabriquant des archets
Bogenbauer der Ojibwa
Luthier de los Ojibwa
Costruttore di archi dell'Ojibwa
boogmaker van de Ojibweg

Grand Canyon, Citadel Walls, Utah

Grand Canyon, Arizona

Winona, Swing bridge

Pont tournant

Eisenbahndrehbrücke

Puentes giratorios del ferrocarril

Ponte ferroviario girevole

spoorbrug

Detroit, Campus Martius, City Hall, Bagley Memorial Fountain, Michigan Soldiers' and Sailors' Monument

Chicago, State Street

Chicago, Wabash Avenue

Chicago, Grain silos

Silos à grain

Getreidesilos

Almacenes de trigo

Silos di cereali

graansilo's

pp. 262/263 Omaha, Trans-Mississippi and International Exposition 1898

51224 THE CAPITOL AT WASHINGTON

COPYRIGHT, 1902, BY
DETROIT PHOTOGRAPHIC CO

Washington D. C., Capitol

Washington D. C., Library of Congress

Atlantic City, Casino

New York, 5th Avenue

New York, Equitable Building                    New York, Statue of Liberty

United States of America/Les États-Unis d'Amérique

New York, City Hall

New York, Manhattan, Laundry day    Montagswäsche        Bucato del lunedì

Jour de lessive                La colada del lunes     maandag, wasdag

New York, Brooklyn, The Circle

New York, Flat-Iron Building, 23rd Street/Broadway

New York, Hotel Astor

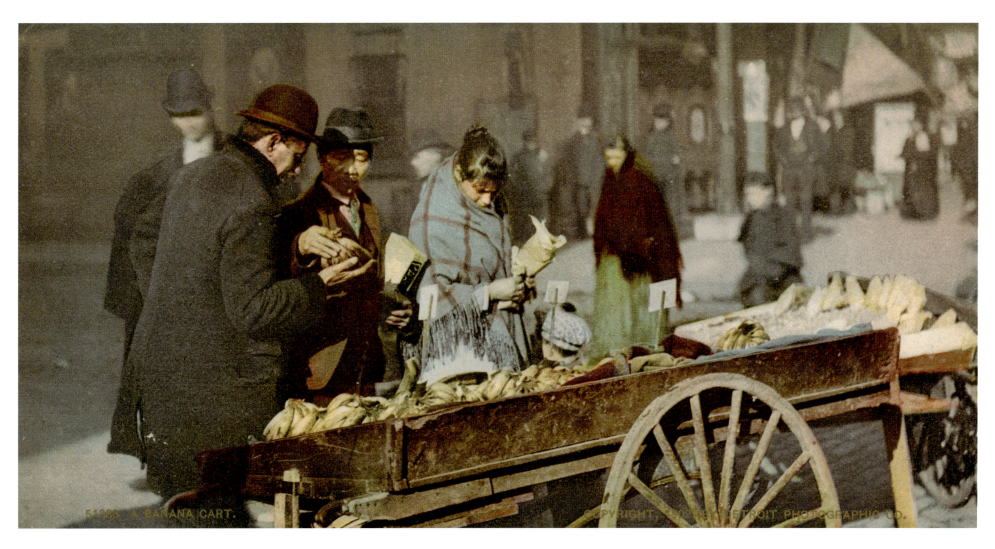

New York, Banana sellers

Vendeurs de bananes

Bananenverkäufer

Vendedor de plátanos

Venditore di banane

bananenverkoper

New York, Manhattan, The Bowery

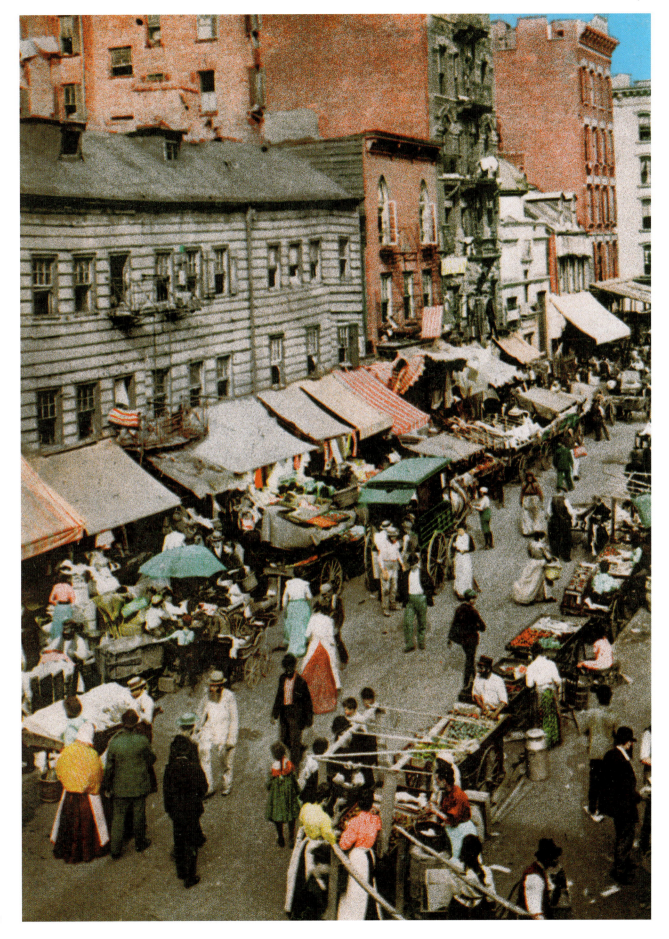

New York, New Jewish Market, Lower East Side

Coney Island

West Point, United States Military Academy USMA

Cambridge, Harvard University, Harvard House

Boston, Massachusetts Institute of Technology MIT

Boston, Old South Meeting House

Buffalo, New York, Black Diamond Express, Lehig Valley Railroad

Niagara Mill District

Niagara Falls, Horseshoe Falls

Montreal

Ottawa, Parliament Buildings, Centre Block

Sainte-Anne-de-Beaupré, Basilique

Quebec, Citadelle, Cap Diamant

51868 CHAMPLAIN STREET, QUEBEC.
COPYRIGHT, 1901, BY DETROIT PHOTOGRAPHIC CO.

Quebec, Rue du Petit-Champlain, Escalier Petit-Champlain

Tadoussac, Dock     Anlegestelle     Approdo

Dock     Muelle     aanlegsteiger

Toronto, Parliament Buildings, Northwest Rebellion Monument

Selkirk Mountains, Rogers Pass, Mount Sir Donald

Ciudad de Mexico, Paseo de la Reforma

Ciudad de Mexico, Plaza de Armas

Guanajuato

No. 195. Mercado en Texcoco.
Market of Texcoco.

México.
Mexico.

ALMACEN DE ROPA Y NOVEDADES.

Texcoco de Mora, Almacen de Ropa y Novedades

Santos, Holophote do Itapema

Buenos Aires, Jardin Zoológico

Buenos Aires, Paseo de Julio

Tandscha, Kasbah

Dzayer

Dzayer

Dzayer

Dzayer, Jamaà El Jdid

Dzayer, Arabs with children        Araber mit Kindern        Arabo con bambini

Arabes avec enfants        Árabe con niños        Arabieren met kinderen

Dzayer, Moorish woman and child on a terrace  Maurin mit Kind auf einer Terrasse  Donna moresca con bambino su una terrazza

Femme mauresque avec enfant sur une terrasse  Mora con niño en una terraza  Moorse met kind op een dakterras

Dzayer, Men arguing          Streitende Männer          Uomini che litigano

Arabes se disputant          Hombres peleando          discussiërende mannen

Sidi Uqba

Biskra

Biskra

Biskra

Qustantinah, Pont d'El Kantara

Tunis, Kasbah

Kairouan

al-Qāhira/Cairo, Sailboat     Segelboot          Barca a vela

Felouque sur le Nil           Bote de vela       zeilboot

al-Dschīza/Gizeh

# Index